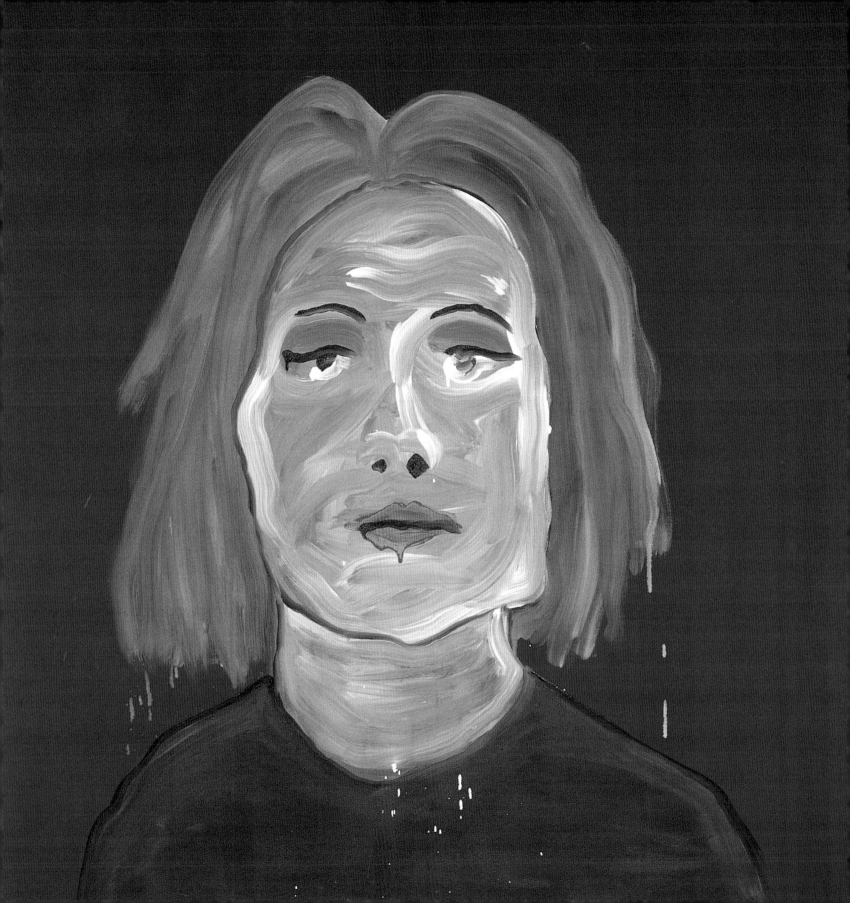

ADAM CULLEN
SCARS LAST LONGER • INGRID PERIZ

New Art Series Editor: Ashley Crawford

CRAFTSMAN HOUSE

First published in Australia in 2004 by Craftsman House
An imprint of Thames and Hudson (Australia) Pty Ltd
Portside Business Park, Fishermans Bend, Victoria 3207
www.thamesandhudson.com

National Library of Australia Cataloguing-in-Publication data.

Periz, Ingrid
Adam Cullen
ISBN 0 9751965 2 9
1. Adam Cullen I. Title.
709.2

Editing: Bala Starr
Design: Terence Hogan
Production: Publishing Solutions Pty Ltd,
Victoria, Australia
Printed in China

Author's Acknowledgments:
Ingrid Periz would like to thank Adam Cullen, Andrew Frost, Trevor Smith,
Bronwyn Clark-Coolee, Kerry Crowley, Natasha Kok, and Mark Loreto.

Frontispiece:
DISGRACE 2003
acrylic on canvas, 183 x 183 cm

Australian Government

Australia Council
for the Arts

This project has been assisted by the Australian Government through
the Australia Council, its arts funding and advisory body.

CONTENTS

My thanks to Yuill/Crowley Gallery, Sydney, and all those involved in the production of this book. Thanks also to my family and friends (they know who they are) and my dog, Growler.

Adam Cullen

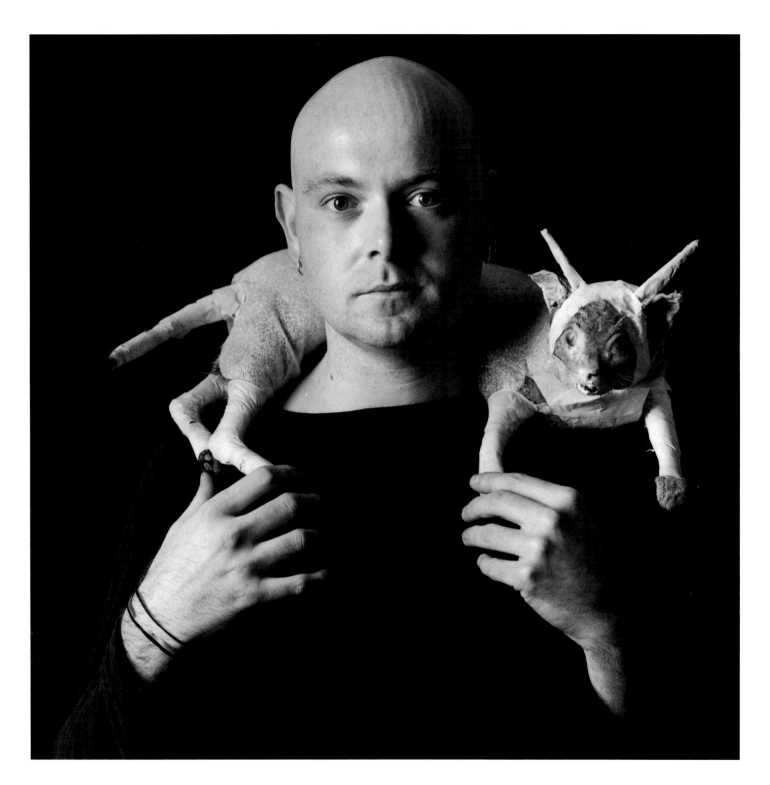

Adam Cullen

Photo: Martin Kantor, 1994

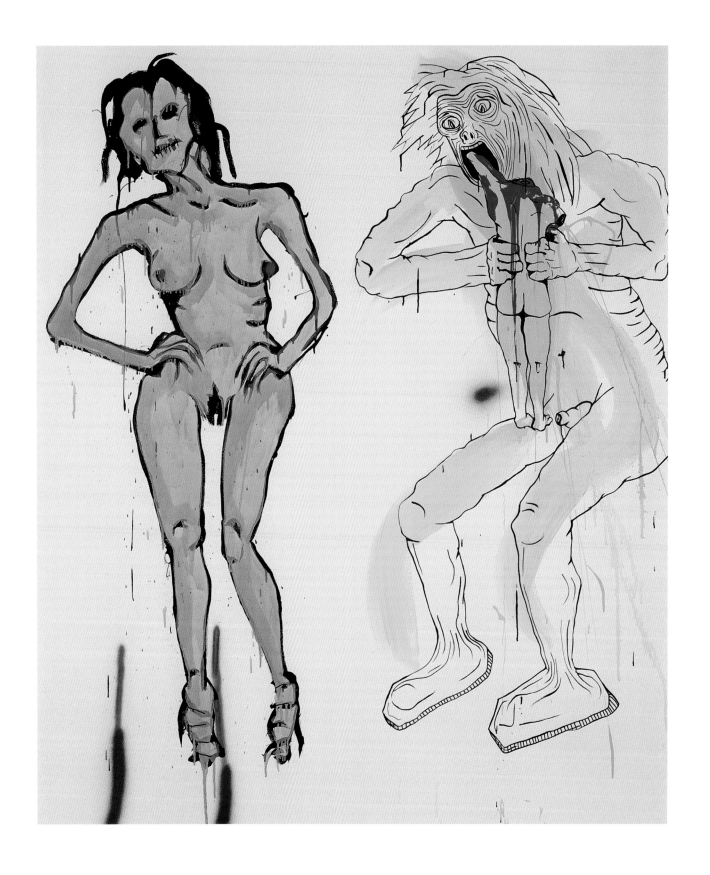

SCARS LAST LONGER

THE WORK OF ADAM CULLEN
By Ingrid Periz

Dead cats, bloodied 'roos, inflatable men and headless women. Sydney painter Adam Cullen likes to conjure up the elements of a place called 'Loserville', pipe in some lounge music and depart the scene, but not for anywhere better. No such place exists in Cullen's world, only endurance in the present, relieved by occasional cheap notoriety, painkillers and booze. Or so he, and some eager myth-makers, would have you believe. Cullen's grungy bad-boy persona is about to be undone.

A child of Sydney's northern beaches who drew before he talked, Cullen always wanted to paint. Confronting Goya's *Saturn Devouring His Son* (1819/1823) in the Prado, the 10-year-old boy was struck dumb, his vocation affirmed. As he recounts it, 'I was absolutely in awe. I thought this is exactly what I want to do, it's amazing. How long has this thing been happening – 300 or 400 years? God, I have to do this'.

Cullen is a master of the anecdote and this one, often repeated, has all the hallmarks of a road-to-Damascus conversion. Still, it can't be dismissed if only because his own work replays the Goya effect. Viewers are left speechless, critics often gag and gurgle. A hostile writer called him a 'millennially bad painter', a supportive one recommended viewers 'repair to the couch with a six pack'.[1]

Cullen paints, draws prolifically, makes etchings and plans for sculpture. In the past he's worked with performance, stand-up comedy, video, ceramics, and all manner of aesthetically unredeemable materials like disposable nappies, disinfectant tablets, air-conditioning filters and road-kill, making objects in what he calls 'installments'. He played trumpet, briefly, for the legendary Sydney punk band Feedtime and along with a half-dozen other part-time jobs he worked briefly for an undertaker. As a teenager, he painted straight-faced landscapes in the Heidelberg tradition and kept a still. He's a bit of a bushman, but for aesthetic rather than political reasons, and when asked if he's about to start painting plein-air, he maintains, 'No easels in the bush'. His work can be funny, shocking, sometimes almost unviewable. Lately he's been

Facing page:
SHE MUST HAVE KNOWN 2001
ink, enamel and acrylic on canvas
183 x 152 cm
Private Collection

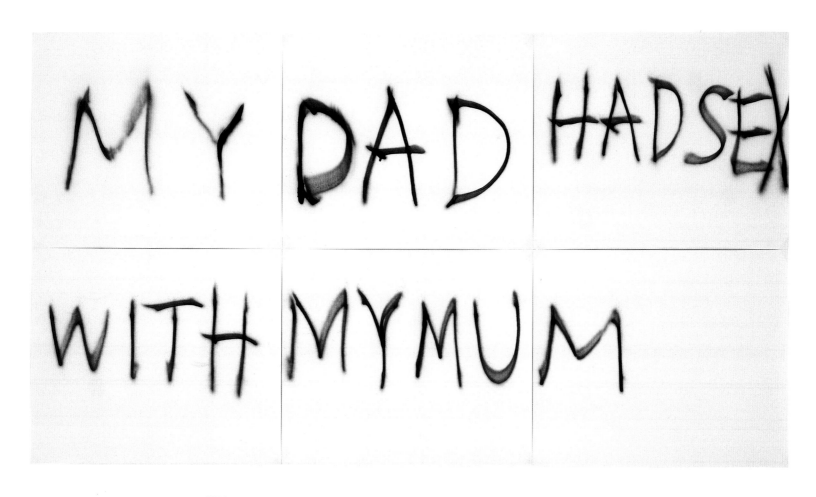

MY DAD HAD SEX WITH MY MUM 1996
enamel and ink on photographic paper
100 x 200 cm

edging towards beauty. It's difficult to remain unmoved one way or another, especially when Cullen likes to puncture the niceties of political correctness with titles like *UNDERPANTS DREAMING* (1998), or otherwise state the obvious in *MY DAD HAD SEX WITH MY MUM* (1996). Drawing drives his practice, along with a strong figurative impulse. Even when Cullen is not portraying his often strangely embodied humans, an embodied humanness is palpable. *STIFF*, an installment from 1991, put a skeletal bed-like platform in a room where the walls, floor and ceiling were covered with plastic. No body was apparent here, but its potential messy dissolution and hasty clean-up was implicit in Cullen's arrangement. Other times, the body is just a head, a mental space banging up against the limits of its containment as in the painting *MY HEAD IS A CAR FULL OF EMPTY BEER BOTTLES*.

His painting conjures up an awkward humanity that's frequently dangerous and often clunky. It is peopled with several recognisably Cullenesque types: male figures whose flesh melts down to the hips where it thickens in folds and useless genitalia, headless females, and garishly pneumatic women who call to mind the word 'floozy'. Popes, crooners, crooks and kangaroos also pop up, with and without antennae, sometimes propped on stilts, in barely sketched landscapes redolent of disconnectedness, dysfunction, and failure where, as Cullen puts it, 'something essential is always missing'.

Christopher Chapman, perhaps Cullen's most sympathetic critic, has called his approach 'heartfelt and serious ... sincere and gentle', and comes very close to finding compassion in the work.[2] The failure that oozes from so many of Cullen's paintings was a feature of many of his objects and installments as well. His objects' impoverished look – a yawning gap between conception and execution – resulted from the wish to give them 'a more human inscription'. 'Scars', he says, 'last longer'.

Compassion may or may not be too strong a word to describe Cullen's gaze at human fallibility and fucked-up mental states. He likes to say his work deals with what we can't or won't think about. *MY DAD HAD SEX WITH MY MUM* is a good example. Cullen often cuts his work with humour and this humour, like the emotional climate of his paintings, resists easy verbal translation. Cullen wants the humour for himself – 'I need to have a bit of a laugh' – as well as for his viewers and, because of this, it's a humour without the knowingness of irony. Unlike a lot of contemporary art, Cullen's work

UNDERPANTS DREAMING 1998
ink and acrylic on board
78 x 112 cm
Private Collection

doesn't comment on art. Neither does art and art history offer him much in the way of material. While nodding to a small group of artists whose work he respects – Nolan, Kippenberger, Dürer, Goya – Cullen is more than happy to look to the visual wash of the everyday for inspiration: television, bus-stop graffiti, advertising, cheap magazines.

Viewers don't need a lot of art literacy to approach his work and this easiness can be disarming. One couple, outraged at a Cullen exhibition some years ago, demanded to know of his gallery, 'How can he get away with it?' Cullen's happy with this response: 'I think there would be something terribly wrong if occasionally that sort of thing didn't happen', but he wonders what it is that viewers think his work gets away with.

His paintings show no self-consciousness about mixing high and low cultural elements. For Cullen it's almost as if the distinction doesn't exist, but he's aware of what jettisoning the difference can do. 'I suppose I look for the lowest common denominators that people are going to recognise and, if you do that, it's almost automatically esoteric because people aren't used to associating low things with high art.' As Chapman puts it, 'It's the normality of Cullen's work that throws people'.[3]

Cullen likes to say that art is a form of palliative care, at best it 'helps' by holding attention. This is a nice conceit because it sets strict limits to what art can do. It's not revolutionary, it's not curative. It simply eases pain by fixing attention elsewhere, although 'elsewhere' in Cullen's work is never too far from the horrible mess we might already be in. When talking about the way his work could hold attention, it isn't Goya that Cullen mentions, it's TV, something he holds in high regard. 'I'm not sure how seriously you should take this', he says, 'but maybe we should look at some of my works in terms of TV, enjoy them like a TV, enjoy them for the same reasons'. A similar kind of attention-holding? 'Yeah', he nods. 'That's all.'

WHAT STICKS STAINS

As a student at Sydney's City Art Institute (College of Fine Arts), Cullen played with appropriate forms of attention-grabbing with two performances delivered before he completed a Bachelor of Fine Arts in 1986. In one, accompanied by mood lighting and The Doors' 'Hello I Love You', Cullen skinned a road-killed cat, wore the carcass around his shoulders, and then applied make-up to himself and the kitty boa. He called

the effect 'very sexy, very glamorous'. In the other, he removed a pig's head that had been chained to his leg for a period of days in a test of his own artistic commitment. The head, minus its ears, eyebrows, lips and snout, had been encased in a plastic bag and allowed to decompose over this period while Cullen shaved his head and eyebrows in sympathetic mimicry. Removing the head in front of an audience of his peers made for a ritualistic confirmation, a white-boy initiation rite into artistic seriousness at the conclusion of an academic year. In retrospect he concedes, 'It was such an anxiety-driven experience it's all a bit of a blur now'.

He calls going to art school 'an enormous release', in part because it started to answer the question of who he was. It also disabused him of at least one adolescent notion about art.

At that time I wanted to be an artist because that word associated itself with some abstract notion I had of the revolutionary. It didn't take long until I realised that was just a bunch of bullshit. At that time I was headstrong, I think all young people are. I wanted to go over and join the IRA and fight what our family called 'the good war', but of course I was stopped.

Ever since the two dead animal exploits became part of the bad-boy Cullen myth, having been repeated tirelessly by the press early on in his career, the charge of attention-seeking has dogged him. Cullen pushed buttons. After his cat piece, audience members called the RSPCA and the police. Feminists accused him of exploiting his masculinity and tried to have him suspended. Nothing came of any of this. It's difficult to imagine that in a climate of heavily theorised on-campus feminism, Cullen didn't anticipate some of this criticism and possibly invite it. And it would be easy to dismiss Cullen's performances as punkster pokes in the eye hinging on a failed revolutionary impulse, if he hadn't later made the work he did.

Along with painting, performance was one of Cullen's areas of concentrated study at art school where it was the style of choice for a lot of students and gave him, in his words, 'a good fast way to make works that held the audience's attention'. As a medium, performance may have been a student interlude – Cullen soon abandoned it 'when it became less intense and memorable' – but the corollary charge of attention-seeking goes to the core of his subsequent work.

Attention-seeking in art, whether simple exhibitionism or avant-gardist provocation, has a respectable lineage, so too the use of outré materials: Piero Manzoni's canned excrement, Hermann Nitsch's bloody teddies, Mary Kelly's nappy liners, and Damien Hirst's maggoty meat. Cullen's dead cat and rotting porker are in good company. It's his later work that is harder to contextualise. When critics charge an artist with attention-seeking, they usually doubt that there is anything more to the work than its residual shock value, nothing beyond the provocateur's upraised index finger or the exhibitionist parade of 'ME!' and that the work's effect is the result of cheap tactics. (Cullen suffers here because his work, particularly his paintings, can look knocked off, slapdash.) The suspicion is that the effect on the viewer is widely disproportionate to the artist's expenditure of labour, thought, or emotion, and so it is somehow illegitimate. Critic Giles Auty, for instance, complained that Cullen's Archibald Prize money vastly exceeded the 'three hours' worth of time spent on his winning portrait of actor David Wenham in 2000. Viewed differently, however, the work's capacity to collar the viewer's attention could simply be the result of economy, or talent. Ten years ago Catharine Lumby wrote that Cullen's work 'has nothing to do with a simple desire to shock ...'[4] However, his works do shock, and when asked whether provocation is part of his modus operandi, he admits, 'I'd be an idiot if I said it wasn't', but there's nothing very simple about this.

After finishing art school, Cullen spent time in what he calls 'unlearning the institutional stuff', working part-time jobs, and thinking about the kind of practice he wanted. Two years of fairly intense production followed with Cullen making things he had no intention of exhibiting. When work did see the light of day in the early 1990s, it was, as Lumby and other critics noted, difficult to describe, fitting no ready categories. It took the form of installments and objects, generally made of found materials that Cullen altered, and then hung or lounged against a wall, or simply bunched in the corner of a room. Cullen wanted them to look utilitarian, to suggest some sort of function, even if their impoverished materials and homely construction indicated they could never work.

PARENTHESIS (1991), for example, comprised two sheets of foam sandwiched between two sheets of plywood and bound with sticky tape. Attached was a small Perspex vial of formalin containing an umbilical cord, conjuring up a warming device that

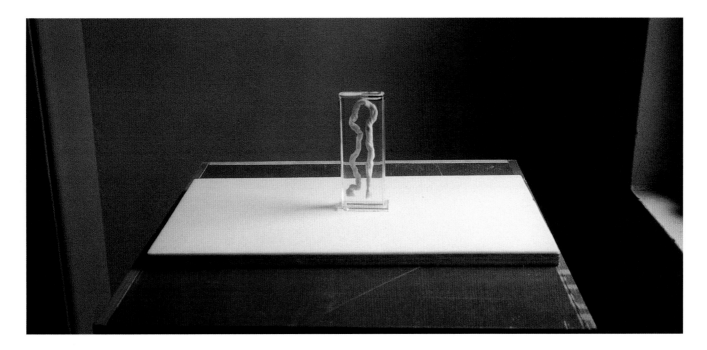

PARENTHESIS 1993
perspex, plaster, wood
size variable
installation: first draft

could keep a hypothetically human form alive. In *HOME SELF REDUCTION UNIT*, a large box sat on plasterboard that had been lined with aluminium foil, evoking a doorless fridge awaiting a body. Cullen has referred to these works as 'formal kinds of machines' that hold on to life or animate the dead and in most of them, as in the bed-like platform of *STIFF*, a human body is implicit. His work for the Art Gallery of New South Wales' 1993 *Perspecta*, *RESIDUAL PAROXYSM OF UNSPOKEN+EXTENDED CLOSURES INTERROGATED BY A MALADY OF NECROGENIC SUBTERFUGE WITH A NICE EXIT* (1993), set up a system for fluid exchange between three objects – television set, bath tub filled with air-conditioning filters wrapped in nappies, and woodchip pallet – all connected by plastic tubing fed through an over-sized hypodermic device. No body was implicit here, simply the internal life support systems freed from their carapace of flesh. *COSMOLOGICAL SATELLITE MOTHER DENIED DEPRESSED SPEECH* (1993), comprising a beer keg with an umbilical cord set in formalin stuck to its side, set up a similar 'system' of life support, invoking in Cullen's words, 'loss, lack, castration, and alcohol', the whole penumbra of Australian masculinity.

Cullen's titles gave the work a humour that undid some of its disquiet. *Parentheses* is a literal bracketing, *HOME SELF REDUCTION UNIT* constitutes a minimal living

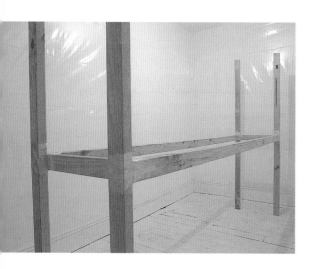

STIFF 1991
clear pastic, tape, wood
300 x 120 x 250 cm
installation: first draft

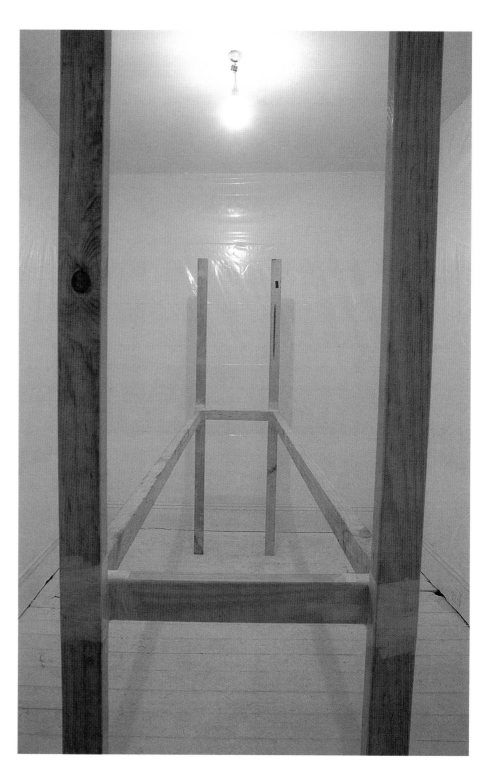

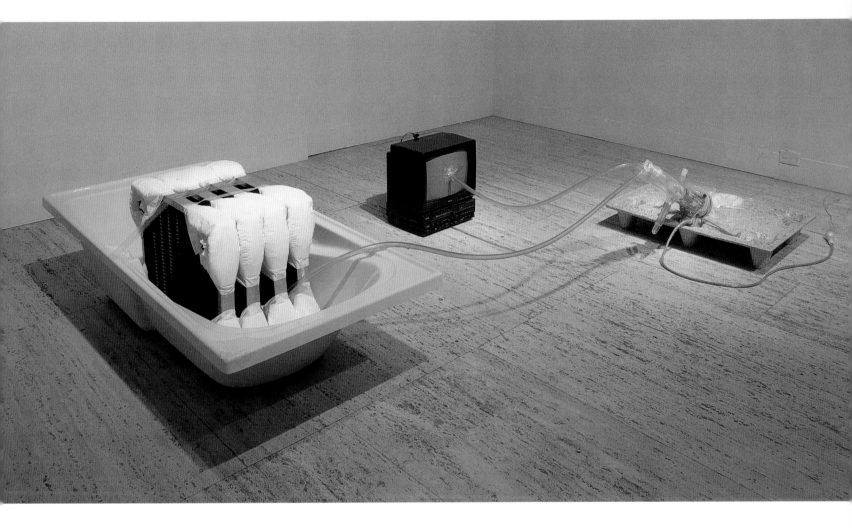

RESIDUAL PAROXYSM OF UNSPOKEN+EXTENDED CLOSURES INTERROGATED
BY A MALADY OF NECROGENIC SUBTERFUGE WITH A NICE EXIT 1993
television, pharmaceutical apparatus, fibreglass bath, disposable nappies,
glass filament, air conditioning filter, adhesive tape, various plastic
mutable dimension
installation: Perspecta 1993, Art Gallery of New South Wales

environment, *STIFF* names what's missing but implied in the work, and *RESIDUAL PAROXYSM* initiates the long list of speedily excessive, possibly intelligible titles that feature in his work. Humour also helped distance the work from then current ideas of abjection and the post-human, both of which, because of their grounding in human corporeality, have some relevance to Cullen's practice.

As a student, Cullen was acquainted with the work of Sydney feminist philosopher Liz Grosz, in particular her writing on literary theorist Julia Kristeva and the concept of abjection. According to Kristeva, abjection is caused by anything that disturbs identity or order: the in-between, the ambiguous, the composite.[5] This betweenness is exemplified by bodily excretions and corpses, for both mark uncrossable boundaries – inside/outside, life/death, identity/non-identity – and both are fascinating while repulsive. As developed by other writers, abjection in contemporary art has tended to coalesce around ideas of wounding, trauma and marginalisation, exemplified in work that often evokes the defilement of formlessness and bodily fluids.[6]

The post-human, by contrast, signals new conceptions of the self made possible through biotechnological, genetic and computer science advances as well as changes in social behaviour. While still grounding the sense of self, the human body is viewed as potentially and infinitely malleable, the self similarly mutable. The question is whether these newly constituted selves comprise a world denuded of its humanity or one of endless self-reinvention.

In the introduction to Jeffrey Deitch's influential 1992 exhibition catalogue called *Post Human*, the challenge to artists is put like this: 'The dawn of the post-human world cannot be portrayed in the same way as the world of Picasso, or even the world of Andy Warhol. Its portrayal demands a new concept of figurative art that takes as much from television talk shows as it does from art history'.[7] Stripped of the techno-fantasies, this isn't too far from Cullen's mature painting.

Cullen's objects and installments, as well as some of his later paintings, pick up on abjection's theorised betweenness – as well as the post-human mutability of the corporeal – but with some important reservations. Formlessness isn't part of Cullen's stylistic repertoire. At the same time, he refuses any post-human celebration of human improvability. Post-human fantasies of perfection become bad suburban dreams in his work – the beauty queen with bad teeth of *TOWN AND COUNTRY* (1999), the home-

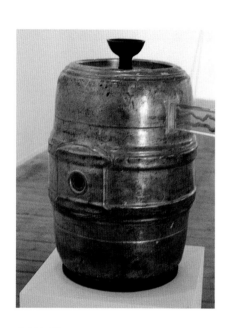

COSMOLOGICAL SATELLITE MOTHER DENIED DEPRESSED SPEECH 1993
rubber, stainless steel, sticky tape, umbilical cord

GLAMOUR PHOTOGRAPHY/
SHAME MONOPOLY 1996
ink, acrylic on canvas
92 x 220 cm
Collection: Gold Coast City Gallery

made weight-loss machine of *HOME SELF REDUCTION UNIT*, the cheap TV promise of *GLAMOUR PHOTOGRAPHY/SHAME MONOPOLY* (1996). Characters in Cullen's paintings are stuck and they seem to know it. Similarly, the considered look of failure worn by many of Cullen's objects tends to deny any reason to cheer. His figurative, and one might say his philosophical, impulse is directed instead toward the residually, fallibly human.

For a very brief time, Cullen was an undertaker's assistant in Newtown, a job he took partly out of dissatisfaction with life-drawing classes at art school. For the same reason he also used to visit the University of Sydney's medical museum. 'I like to draw people on slabs and things', he says, 'also what we called a bucket case'. These were generally elderly people who had been dead for some time and left minimal remains. 'They would actually ooze into the chair or the bed, just leaving a nightie and skeleton and

skin.' Cullen was no stranger to dead animals given his pig-shooting excursions with country cousins – when he skinned the cat at art school, he knew what he was doing – and he was unfazed by either the undertaker's work or the museum's bottled exhibits. He cautions against making too much of the undertaking experience, calling it a starting point to other things rather than an influence, but his work at the time – and indeed later – did not go unmarked. Several titles refer to the remains of fanciful bodily excretions: *DISTILLATION OF SUSPENDED PSYCHO-MUCUS*, *DESSICATED MODULATIONS OF DEPRESSED SPEECH* and *RESIDUAL PAROXYSM OF UNSPOKEN + EXTENDED CLOSURES INTERROGATED BY A MYRIAD OF NECROGENIC SUBTERFUGE WITH A NICE EXIT*, while a number clearly suggest a surface or negative space awaiting an occupying body: *STIFF*, *HOME SELF REDUCTION UNIT* and *AUTO AUTONOMOUS AUTOPSY ON PAROLE*, an installment from the early 1990s which pairs an inverted, wooden, body-scaled 'lid', lined with pieces of discarded Styrofoam packing inserts, and a plastic-wrapped basin on top of which sits a piece of automotive equipment. Cullen's later paintings sometimes portray a body in meltdown. In *WHY WE ARE* (2003), for example, Cullen's bleeding acrylics undo his underlying outlines, as if the paint were washing away or corroding any underlying form. What's left is a drippy stain dragging downwards with gravity itself undoing the figures.

These different suggestions of mortality don't translate to abjection, with its vertiginous suspension of the subject's identity, so much as the simple fact of human perishability. Cullen's preference for making scarred-looking objects – the scar being a way of humanising them, in his terms – has its painterly equivalent in his predilection for depicting losers and the otherwise maladjusted. The built-in fallibility of his painted subjects and installed objects is part of what might be called Cullen's 'realism'.

Grunge rather than realism was the immediate critical context for Cullen's work during 1990–93. His use of scavenged material was part of a generational turn to detritus, the discarded, and the aesthetically unredeemable in Australia and internationally. Grunge delighted in aesthetic and attitudinal badness, incorporating low-rent infantilism at one end and more theorised interest in abjection at the other. In 1993, local exhibitions like *Shirthead* at the Mori Annexe, *Lucifer* at Yuill/Crowley, *Rad Scunge* at Karyn Lovegrove, and *Monster Field* at the Ivan Dougherty Gallery established a roster of grungistes, many of them living, like Cullen, in Sydney's Newtown.[8]

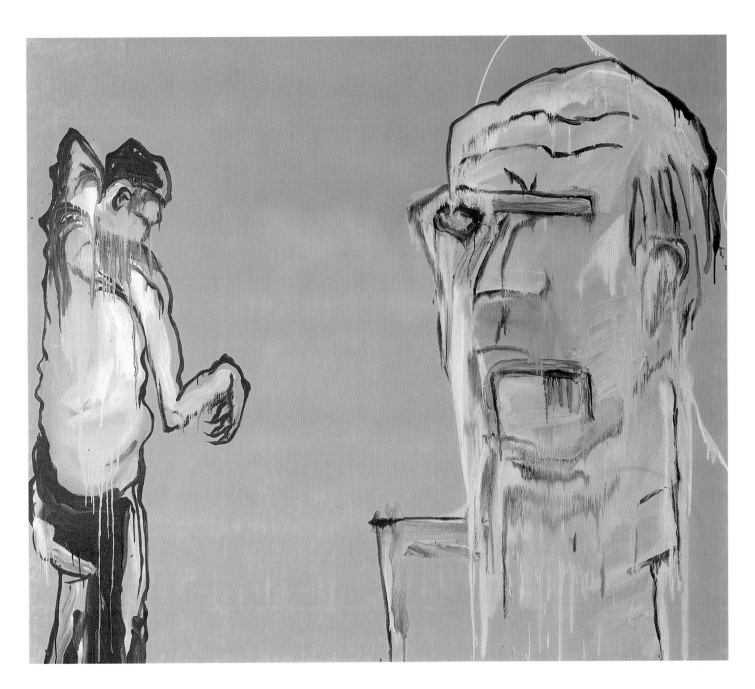

WHY WE ARE 2003
acrylic on canvas
244 x 244 cm
Collection: BHP Billiton

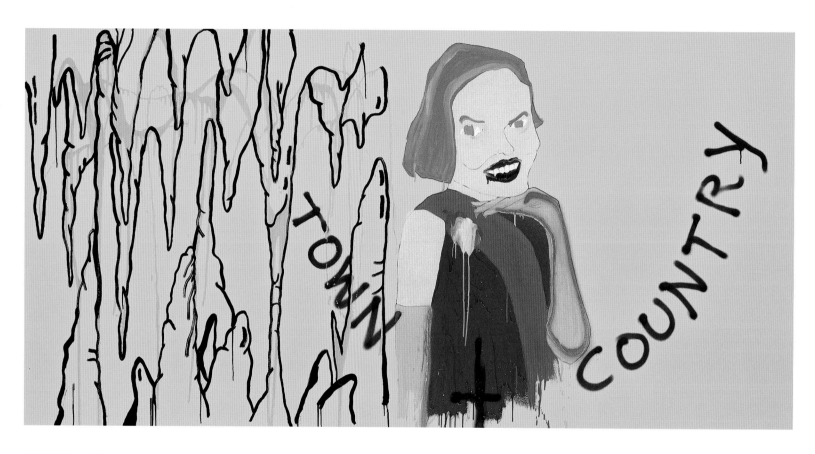

TOWN AND COUNTRY 1999
ink, enamel and acrylic on board
120 x 240 cm
Private Collection

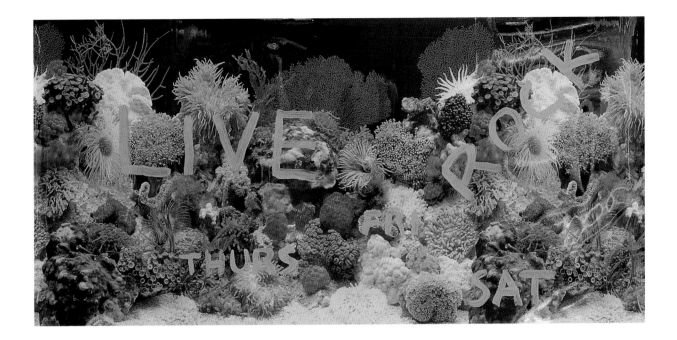

LIVE ROCK 1995
acrylic on paper
100 x 50 cm

Although Cullen spent only six months or so in the grunge milieu, where his compatriots were Hany Armanious, Mikala Dwyer and Tony Schwensen, he calls the common attitudes and the resulting mix of work and play 'liberating', and adds, 'it was like a finishing school'.

Whether grunge sought to dismantle aesthetic judgment, or simply forge a different aesthetic – by 1993, many of the artists had already moved from alternative spaces to mainstream galleries – Cullen's relationship to grunge's outré status needs considering. As an adolescent, he had painted proficient landscapes in the Heidelberg tradition and, working as a preparator at Sydney's maritime museum, he knew how to construct successful, convincing objects. The 'bad' look of Cullen's objects from this time – the gap between conception and execution – was quite considered, but it was never part of an anti-aesthetic criticism of the way fashion and the market could recuperate just about anything. 'Badness' wasn't a tactic to prove a point but part of Cullen's expressive vocabulary. The failed quality of the objects would become the themes of his paintings, but not immediately.

Cullen occasionally used a layering impulse to scarify his work. Works were bandaged with tape or superimposed with text, this latter practice continuing through his

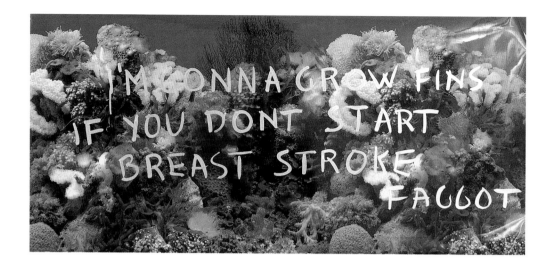

THE MOON WAS A DRIP ON A
DARK HOOD 1995
enamel on photographic paper
approx. 70 x 110 cm

Facing page:
THE OTHERNESS WHEN
IT COMES 1993
cat, ethafoam, masking tape,
gel toothpaste
approx. 80 x 30 x 20 cm
installation: Black Gallery
Private Collection

early paintings. Some pieces were sticky-taped to the wall or painted with Estapol, another kind of layering or lamination, in a consciously failed attempt at glamour. THE OTHERNESS WHEN IT COMES (1993), a dead cat, stuffed and bandaged, its face painted toothpaste blue and sporting feline antennae, stands out from this time because of its combination of humour and pathos.

Overlaying found images with text made for a different kind of lamination. In LIVE ROCK (1995) Cullen wrote 'LIVE ROCK THURSDAY FRIDAY SATURDAY' across aquarium background paper, transposing his elaborate titles onto the found image itself. This defacement set up the tortured, humorous mismatch between text and image that later characterised many of his paintings. It also allowed Cullen to play around with the valency of different kinds of marks; here, the graffiti's urgency against the banal photographic fantasy of marine prettiness. In THE MOON WAS A DRIP ON A DARK HOOD (1995), where Cullen painted the words, 'I'm Gonna Grow Fins if You Don't Start Breast Stroke Faggot', there is the additional interjection of a personal voice, which may or may not be Cullen's.

This use of text, along with the manic titles, contributed to the sense of chemical-fuelled abandon driving Cullen's practice. Reviewing Rad Scunge, Jeff Gibson noted COSMOLOGICAL SATELLITE MOTHER DENIED DEPRESSED SPEECH and commented: 'The reference to intoxicating substances and addiction/dependency speaks volumes

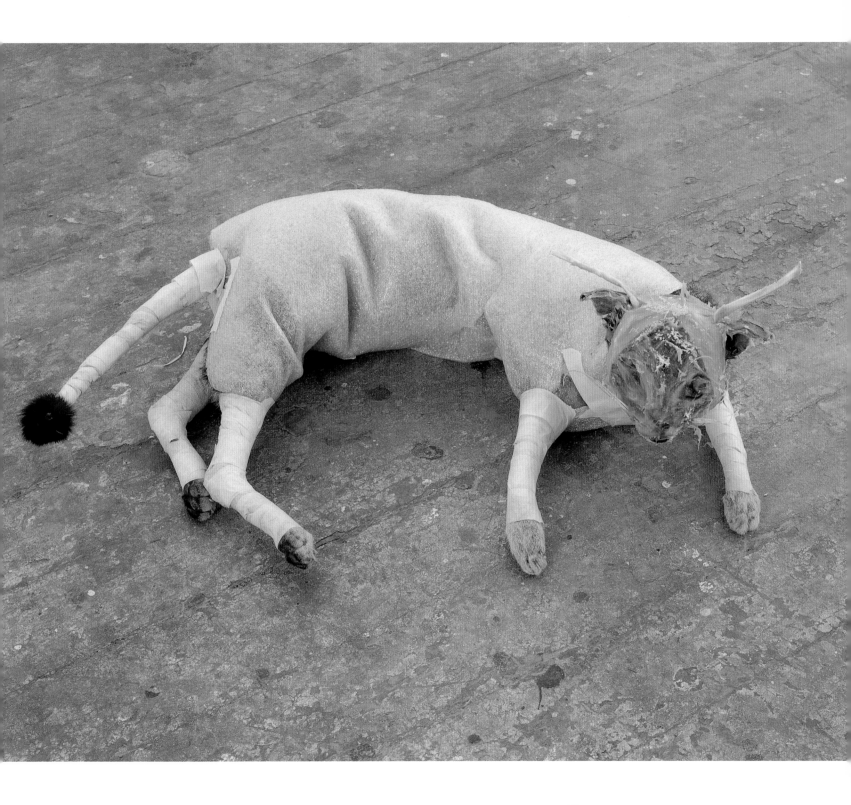

about much of this work. There is a kind of drunken logic circling across all of this detritus that screams Dionysian abandon'.[9]

In his MFA thesis from 1998, Cullen acknowledged that his work from this time 'reflected extreme intoxication and a preoccupation with death and an impossible transcendence'. He called the later aesthetic straightening out of his grunge cohorts and himself 'a severe case of amphetamine psychosis'. He continued: 'The name of the game was abjection and the body, but I was producing a dessicated art that lacked fluidity'.[10]

The maternal body is one of abjection theory's favourite subjects, but when he tackled it in the mama keg of *COSMOLOGICAL SATELLITE MOTHER DENIED DEPRESSED SPEECH* the result was as funny as it was horrifying. In conversation Cullen stresses the fact that ideas about abjection, about the body and its messiness, have little bearing on his work. He is more concerned with what the body displaces and what spaces are left behind by this. And while Cullen distances himself from the psycho-analytic models beloved of abjection theory, these 'spaces' would seem to be psychic as much as physical.

Although Cullen was drawing continually, as yet there was no desire to transcribe this into paint. His paintings as such from this period showed a fondness for surfaces that made paint adhesion difficult – one group of paintings used Estapol on blue plastic bed-liners masking-taped to the wall – suggesting Cullen was biding his time, waiting for appropriate content. *SPECIAL MONOCHROME ARTIFICIAL SPEECH* (1993), highly reflective zinc primer on board, is an anomalous, if premature, transition. Inspired by heavy metal music, Cullen calls this a 'one-chord painting', but, sticky-taped to the wall, it seems to exist as another object rather than a painting per se. One year later, *HIGH FIDELITY SPEECH ARRANGEMENT WITH A STRATEGY*, oil paint and acetone brush 'drawings' of objects on acrylic paper, signalled a further move. Blobby and unstable because the liquid finds no ready purchase on the surface, these works nevertheless showed Cullen he could do more with painting objects than making them. He also began incorporating drawings into his 'installments', initially placing them on the floor. He later sticky-taped reworked junk mail, institutional stationery and educational materials to the wall, continuing in the vein of modifying found objects by treating them as marked-up surfaces ripe for his additional graphic commentary.

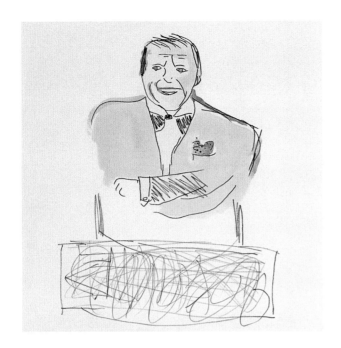

STUPID EVERYTHING 1995
acrylic on canvas.
2 panels, each 61 x 61 cm

Cullen's turn to painted images was aided by a child's sketchbook of tiny drawings, found on a Redfern street. Altering and enlarging them, he added colour with diluted acrylics on white canvas ground. *STUPID EVERYTHING* (1995) were the first canvases Cullen showed since leaving art school. These are gentle, almost pretty images that retain their drawn origin. Lacking any verbal inscription, or indeed any of Cullen's bite, these little icons of Beethoven, forests, crucifixes and Sinatra caught viewers 'on their left foot', as he remembers. After completing them he was painting daily.

PUP, YOUR MOUTH'S TOO BIG FOR YOUR BODY

When discussing his objects from the early 1990s and their bodgy, hand-made look, Cullen talks about his ideas for them exceeding his execution. Despite their appearance, 'I'm trying to make them work', he says. 'I'm trying to make an idea but the idea is way ahead of the materials or the execution. Like our brain's too big, the technology won't allow me to make that work.' This distance between conception and execution is doubled by Cullen's elaborate titles: *COSMOLOGICAL SATELLITE MOTHER DENIED DEPRESSED SPEECH, DESSICATED MODULATIONS OF DEPRESSED SPEECH, RESIDUAL*

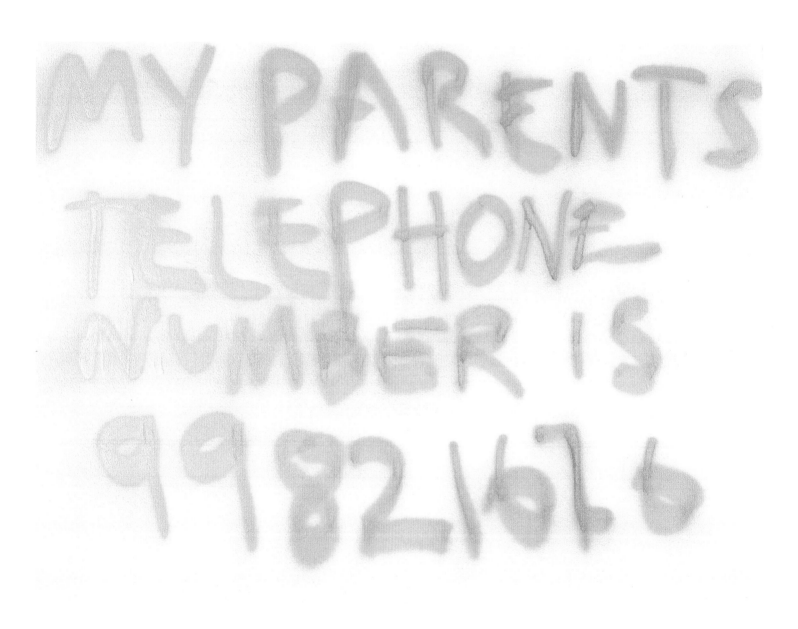

MY PARENTS TELEPHONE NUMBER IS 99821626 1996
enamel on canvas
92 x 220 cm
Collection: Gold Coast City Gallery

PAROXYSM OF UNSPOKEN + EXTENDED CLOSURES INTERROGATED BY A MYRIAD OF NEC-ROGENIC SUBTERFUGE WITH A NICE EXIT, DISTILLATION OF SUSPENDED PSYCHO-MUCUS, AUTO AUTONOMOUS AUTOPSY ON PAROLE. In their very excess, these titles suggest a gap or mismatch between language and its objects, as if language itself has run amok, grown 'too big'. Here, Cullen's words run away from him and in some of his paintings shortly after *STUPID EVERYTHING*, text predominates: words are the image.

It's worth remembering that Cullen drew before he talked, was left dumbstruck by Goya in Spain at the age of ten, and began to stammer when he returned with his family to Sydney. (Today, Cullen shows none of his earlier verbal hesitation. He tells a good yarn.) In the battle between words and images that played itself out in the boy-child, pictures won but in some of the earliest paintings exhibited as an adult artist this wasn't the case. In paintings like *AS IF*, *MY DAD HAD SEX WITH MY MUM*, *MY PARENTS TELEPHONE NUMBER IS 99821676* (1996), *GLAMOUR PHOTOGRAPHY/SHAME MONOPOLY* and *MY HEAD IS A CAR FULL OF EMPTY BEER BOTTLES*, Cullen eschewed images entirely. Language here isn't running awry, it's quite precise – *AS IF* is a rare self-referential joke – with Cullen using words to indicate the themes of family drama, intoxication, and TV transformation that punctuate his paintings. Some play on audacity but Cullen knew that for all the attention-grabbing potential, dependence on text alone made for work that jeopardised its own staying power.

As a part of his development as a painter, however, working with text could serve formal ends. A good example is *PLAYSTATION* (1997), a text painting executed and shown in New Zealand while Cullen was a visiting artist at the Dunedin Public Art Gallery in 1997, and part of a resulting group of works that illustrates this development. Using a black rectangle positioned in the upper half of the picture plane to effectively hold the arrangement, Cullen is able to contrast different marks – drips, the runny viscosity of painting wet over wet, spray versus 'drawn' painted letters – while using the left-to-right linear convention of reading as a compositional device. Just as he had worked with discarded materials of limited aesthetic interest, Cullen's own lexicon of marks was grungy. He used the frustrated doodling of adolescent boredom with all its attendant repetitiveness and toilet humour, the obsessive's list, the graffiti's angry barb, and the full range of spray-paint's possibilities. *PLAYSTATION* is painterly, to the extent that its surface is marked exclusively by paint, but other

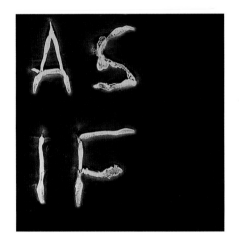

AS IF 1998
enamel on board
50 x 50 cm
Private Collection

paintings work with the different ways that inscribed words read when spray-painted, biroed, or felt-penned onto the canvas.

'Reading' here is both a semantic and a visual process, with Cullen exploiting both the meaning as well as the graphic and compositional force of his verbal marks. *THE MAN IN WHITE (first and second panels)* (1997), also from the Dunedin exhibition, plays off spray-paint, biro and brushed paint on Fomecor in compositions that look like transcriptions from sketchbooks with additional layers of text. The work has a graffiti-like quality, the result of Cullen's paint-dripping urgency, the meanness of biro on Fomecor, and a general feeling of defacement – the spray-painted map of Australia on top of the punk face, the wings and penis/sausage added to the figure, the textual additions. Although undeniably grungy in feel, its grunginess is accomplished, almost studied in how it's put together. Cullen's humour lightens the load – the lopped-off feet transformed into chicken drumsticks, as well as the legend 'Jesus was Snow-white/Snow White and Dopey/and Your the Wicked Witch'. Unafraid of getting so close to looking puerile, Cullen comes off looking generous.

Two other works from the Dunedin exhibition show Cullen taking the elements of a graffitied surface and developing them. *EVERY DAY I GET HALF AN HOUR OLDER* (1997) divides the landscape-formatted Fomecor into a triptych, the first 'panel' of which suggests a generic alpine landscape, and the two following, a crooner and jazz trumpeter Chet Baker. Cullen plays with some orange and silver painterly effects in the top-left corner above a levitating headless kangaroo and includes a list of confectionery 'dreamings' (Mars Bar, Kit Kat, Snickers, etc.). His portraits of the two performers hint at his skills in caricature, but he ghosts both with failure and morbidity. It's this emotional climate of the painting that separates it from *THE MAN IN WHITE*. Here, Cullen's additional text – his 'dreamings', the 'trans-Tasman Frank Sinatra Impersonator' under the crooner, the vertical 'vulgar display of power' by Baker – play less of a semantic role in the overall feeling of the painting, although they are important compositionally. Indeed, as *THE AGE AND SIZE OF THE WORLD* (1997) shows, increasingly Cullen could rely simply on placement and paint for his effects. Sparer iconographically than the preceding work, this one loosens the triptych arrangement, using only four elements: minimal text – 'The Best of Desmond Dekker' – a loosely painted sketch of Dekker, a felt-penned stork carrying an infant, and a large drippy

splodge of metallic silver spray-paint. Laying out his elements this way and down-playing the graffiti writer's urge to comment, he lets the different graphic weight of his marks carry much of the painting's force.

Cullen's shift from objects and installments to painting can be understood in part as a gradual weakening of his reliance on words. As his painting has grown more assured, the tongue-twisting titles have become simpler, and textual elements have largely disappeared from the canvas. (Whether they will become important again in the future remains to be seen.) Words still have a place in Cullen's prolific drawing where, instead of drawing a cow, he might write 'cow' and work with the fact that this 'looks weird'. Drawing continues to provide the basis of his painting. 'Everything is drawn', he says. 'Even if I don't actually draw it', it has some prior existence as a note or sketch of an idea in a notebook. As we shall see, the relationship between drawing and painting in Cullen's painted works has changed over time, with some of his most recent work largely abandoning drawn lines in favour of a more painterly modelling.

One of the things that appeals to Cullen about painting is what he calls its 'perfor-mativity' and here *HIGH FIDELITY SPEECH ARRANGEMENT WITH A STRATEGY*, the oil paint and acetone brush 'drawings' of objects on acrylic paper, was instructive. As he recalls, this medium 'almost had a mind of its own. I had absolutely no control over how it would eventually look. Even though it's dry, it permanently looks wet. It started the ball rolling for my increasing interest in painting'. Making objects, he rarely encountered accidents, but painting was different, particularly with the very viscous paint he frequently used. Spray-paint too has its own performative dynamic quite apart from the connotations of graffiti artists' night-time raids: hold the can too close or the nozzle too long and the paint pools outwards, so that the more that is applied, the less stays in place. No amount of drawn preparation can forestall these elements of chance or risk. Cullen works quickly, but the hands-on moment is only the last stage of the process. He will think about the work for a while – anywhere from a couple of hours to months – and begin with preliminary drawings and doodles. In addition there are notes, 'usually more notes than there is actual scribbling out of form and stuff', and all the required colours opened and set up within easy reach. Once he starts he doesn't stop, everything 'has to work there and then' in what he calls 'this one-staged execution'. It's in the painting process that Cullen gets to learn

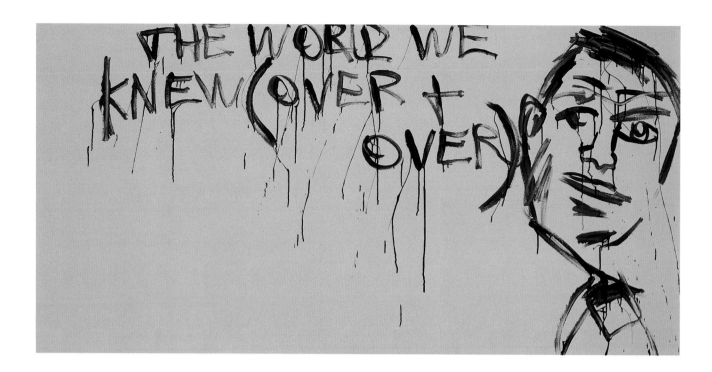

about the work, rather than the planning or the subsequent detached viewing after completion. He stakes a lot in this and jokes that his model here is Viennese Aktionismus painter Hermann Nitsch, who advised followers to 'drop acid in a room'.

Cullen uses hardware-store-bought acrylic and enamel, sometimes together, and sometimes on top of each other. He works over wet paint and shifts the painting from vertical to horizontal axes, moving it from the wall to the floor and back and forth. As he puts it, he works the picture a lot, 'there's a lot of handling'. This back and forth process happened spontaneously and it's now incorporated into the arrangement of his studio although occasionally he has to keep his dog from walking over drying paintings.

Blindside, a 1999 touring exhibition, showed Cullen doing more with less. Using a strongly horizontal format, he downplayed the graffiti-laden surface in favour of sparer compositions. *TAIWAN JAZZ* (1999) sets down three images – midriff with underpants, half-portrait, and skull – on an acid yellow-orange background in a triptych. In *YOU'RE BREAKING MY HEART* (1999) an area of red and yellow spray-paint, puddling and dripping downwards, is matched by an almost caricatured sketch of Stephane Grapelli. What stops this pairing from being flaccid is a streak of white paint dripping

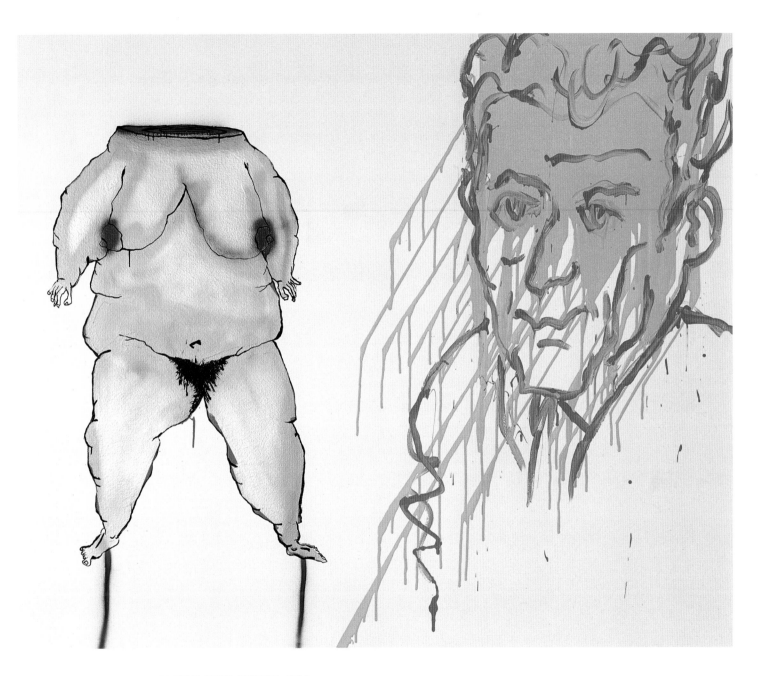

SHUT UP, NOBODY WANTS TO HEAR YOUR STORIES 2000
enamel and acrylic on canvas
152 x 183 cm
Collection: Art Gallery of Western Australia

from the top of the canvas through Grapelli's violin and pulling attention back onto the surface. *THE WORLD WE KNEW* (1999) tests the limits of the horizontal format. Sinatra looms on the extreme right with the hastily painted words, 'The World We Knew (Over + Over)' in the top half. Cullen used a viscous paint that required some pushing. Deep drips leak down from the words and from Frankie in a manner suggesting both bloody tragedy and the clichés of lost youth.

The horizontal format – twice as long as it was wide – made for dynamically balanced works, given Cullen's habit of pairing one image with another. When he uses a squarer or more portrait proportioned canvas, the dynamics change. And, when these canvases have a coloured ground, Cullen's images hold the wall in a completely new way. Compare for instance *SHUT UP, NOBODY WANTS TO HEAR YOUR STORIES* (2000) and *WORKING DOG (GROWLER)* (1999). In the former, a headless female body and a rather handsome male portrait occupy a white canvas. The female is outlined in black with minor modelling of the flesh. The nipples are spray-painted crimson and, like a lot of Cullen's figures, the figure is propped by two spray-painted supports under the feet. This tethers the figure graphically to the bottom of the canvas while giving it a measure of surrounding pictorial space it would otherwise lack. The male is drawn in orange over a yellow swath of paint that has dripped diagonally, indicating Cullen's shifting orientation of the canvas during the painting process. The head is partially cropped by the edge of the canvas and this, coupled with the two images' different sense of scale, also adds to a nascent sense of pictorial space. In *I WALK THE LINE* (2002), another work pairing two images, similarly scaled cartoon cats loom up from the bottom of the canvas, both on the same plane but without any sense of pictorial depth, a sensation aided by Cullen's textual additions – 'The love boat is your home' and 'I walk the line' – which render the surface flat and notebook-like. *WORKING DOG (GROWLER)*, Cullen's portrait of his dog, is very different. Heavily outlined in black, the dog is centrally positioned in a strong yellow ground, its muzzle detailed with drippy paint striations otherwise exploited by the crafts of water marbling on paper and fancy cake icing. Here, there is a sense of the image fully occupying the painted picture-plane which, thanks to the colour, marks itself off from any supporting wall.

We've seen before that Cullen's drip can corrode, as paint eats away at underlying drawing. The drippy effects that dissolve Growler's nose complicate the sense of

Facing page:
WORKING DOG (GROWLER) 1999
enamel and acrylic on canvas
152 x 152 cm
Private Collection

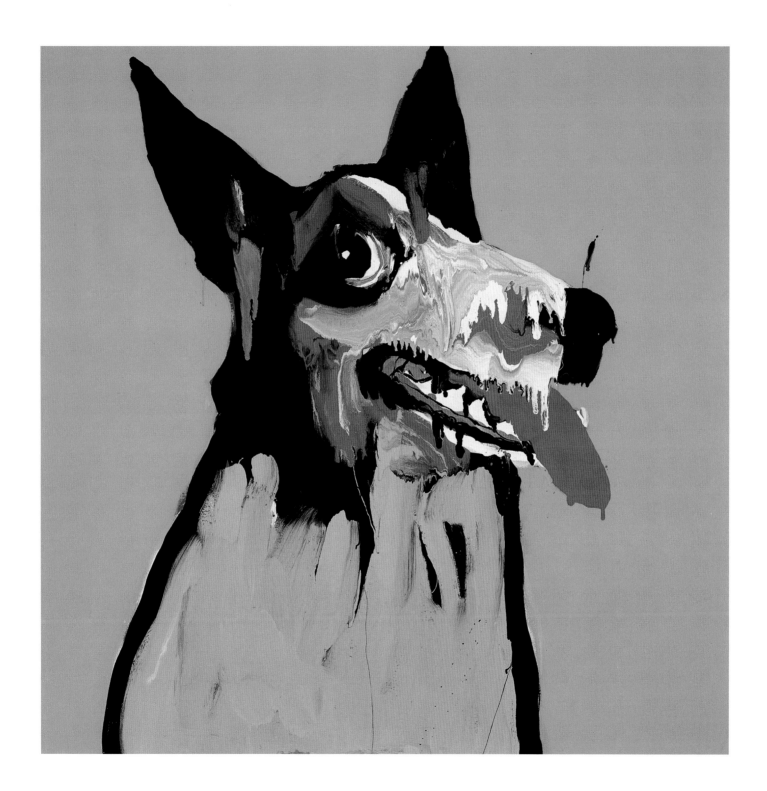

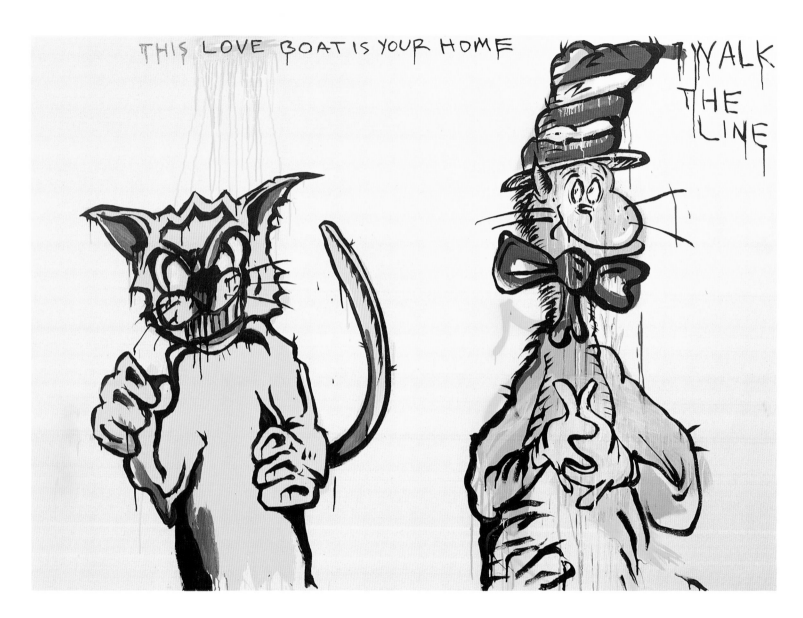

I WALK THE LINE 2002
ink, enamel and acrylic on canvas
152.5 x 213.5 cm

pictorial space, pulling us back to a surface that is difficult to locate spatially. In *WE LIKE NEW AUSTRALIANS BECAUSE THEY KEEP SHIFTING THE GOAL POSTS* (1999), executed at around the same time, Cullen's drip both corrodes and marks-up the surface as a large swath of flesh-coloured paint dominating the upper half of the composition drips down and begins to eat away at the two embracing figures. At the same time, this stripping also fleshes out the minimal sense of landscape suggested by the picture's high horizon line. Cullen's loosely worked lines of paint can blur the difference between painting and drawing. The painted lines making up the face in *AUSTRALIAN SAINTS (7 & 9)* (1999) threaten to collapse the face inward as they spool out their own wet-on-wet miscibility.

From the initial puddling resistance of oil paint over acrylic, Cullen has continued to develop a repertoire of painterly marks, and some of them, like the pooling of spray-paint, the way it produces a soft fuzziness of outline that makes precise spatial surface location difficult, as well as the vicissitudes of gravity's drag on wet-on-wet enamel and acrylic, he has made peculiarly his own. In this process, the image-bearing quality of his inscribed surfaces – Fomecor, board, canvas – has changed. Likened variously to a notebook, a doodled Post-it note, or scrawled-upon bus shelter, these surfaces now more closely resemble a conventional painting, with the illusionistic conventions of pictorial space.

Cullen isn't fazed by the apparent conventionality of his later paintings. Despite the unclassifiable nature of his early works, he sees his painting in something like a continuum of art history. In a statement he wrote for an exhibition of *MY PARENTS' TELEPHONE NUMBER IS 99821626*, he put it this way: 'Australia has an amazing painting history ... The entire history of western painting can be reconceived in a bedroom in a suburb in Australia'. Cullen's deflationary rhetoric is on a par with what Chapman called his work's disturbing normality, in this case the particular painting prompting this statement, and its acquisition by a Gold Coast casino. These kinds of distinctions don't matter to Cullen, who began entering portraits in the Archibald Prize in the mid-1990s. Instead of seeing the portrait prize as inherently conservative, he says, 'What's conservative is making those distinctions in the first place – distinctions between traditional and contemporary art, between figurative and conceptual work'.[11]

Critics, as well as some of his contemporaries, might have seen Cullen's Archibald

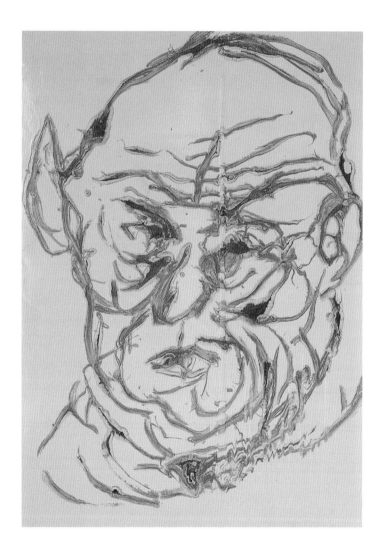

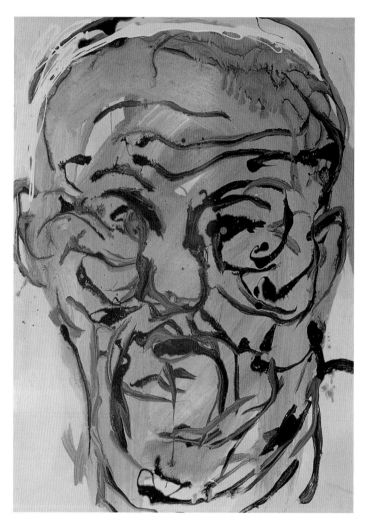

AUSTRALIAN SAINTS (7 & 9) 1999
enamel on board
diptych, each panel 84 x 60 cm
Private Collection

Facing page:
*WE LIKE NEW AUSTRALIANS BECAUSE THEY
KEEP SHIFTING THE GOAL POSTS* 1999
enamel and acrylic on canvas
168 x 168 cm
Private Collection

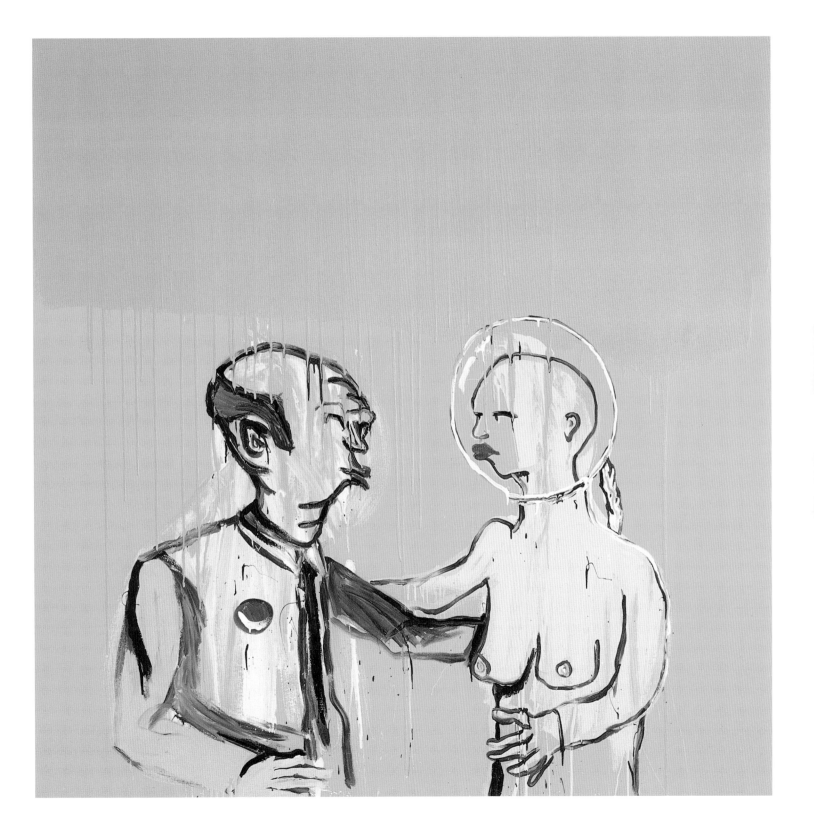

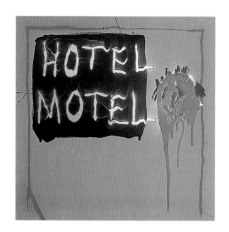

HOTEL / MOTEL 1999
enamel and acrylic on canvas
137 x 137 cm
Private Collection

Facing page:
PORTRAIT OF DAVID WENHAM 2000
acrylic on canvas
182 x 153 cm
Private Collection
Photo: Jenni Carter for AGNSW

entries as mere pranks, in spite of his claim that he was trying to extend the portrait genre by voiding psychological depth in favour of a new 'televisual' way of seeing the subject. Bruce James, for one, understood that Cullen's prankster days had seen their use-by date. Noting a 'newfound lushness of execution and colour' in the 1999 *Hotel/Motel* exhibition, he wrote that Cullen at thirty-three was 'too young to be an old master, too old to be an enfant terrible ... he's between callowness and maturity'.[12] Winning the 2000 Archibald Prize didn't decide the issue either way, although Cullen's portrait of David Wenham fanned the popular controversy that typifies the Archibald. Cullen doesn't shy from notoriety. His socialising with 'Chopper' Read is covered in women's magazines, and his portraits of Anita Coby's murderers in an exhibition designed to commemorate her life drew criticism. What's questionable is whether this kind of notoriety, like the charge of attention-seeking, has anything to do with his work at all. Andrew Frost suggests that the Cullen we see isn't always the Cullen we get, pointing to a gap between the persona suggested by the work and some of its critics, and a more authentic Adam Cullen somewhere else.[13]

Cullen's paintings very often play out this division. In *HAPPINESS (WHERE ARE YOU)* (2002) a red, pointy-eared pope and a decapitated, levitating kangaroo gaze away from each other, never registering their joint presence on the picture plane. This lack of coincidence is typical of many of Cullen's two-figure paintings where each image seems to come from somewhere else. In other two-figure works, such as his portrait of Jimmy Little and a mate, or his doubled portraits of boxers in *ALL SAINTS* and *STUPID NATURE*, he does something different. Here the visual similarities of the figures effectively undo their individuality. Note the shared bloody red of boxing gloves in the pugilist paintings.

The use of Sinatra and Ned Kelly is telling too, for these are mythic figures whose public personas can never coincide with their singular personalities. Cullen has used Australian types similarly, hollowing out what he calls an 'Anglo-Celtic identity crisis'. In *AUSTRALIAN SAINTS* (2000), two dissolving boozy mates hover transposed over the merest hint of Sydney landscape. They look out blindly, as does *HEAD OF A DELUDED MAN* (2003), a very painterly portrait of a Chesty Bond type, and *NEW SOUTH WELSH-MAN (UNCLE ROY)* (2003), a big-hatted, lantern-jawed countryman against a deep blue background.

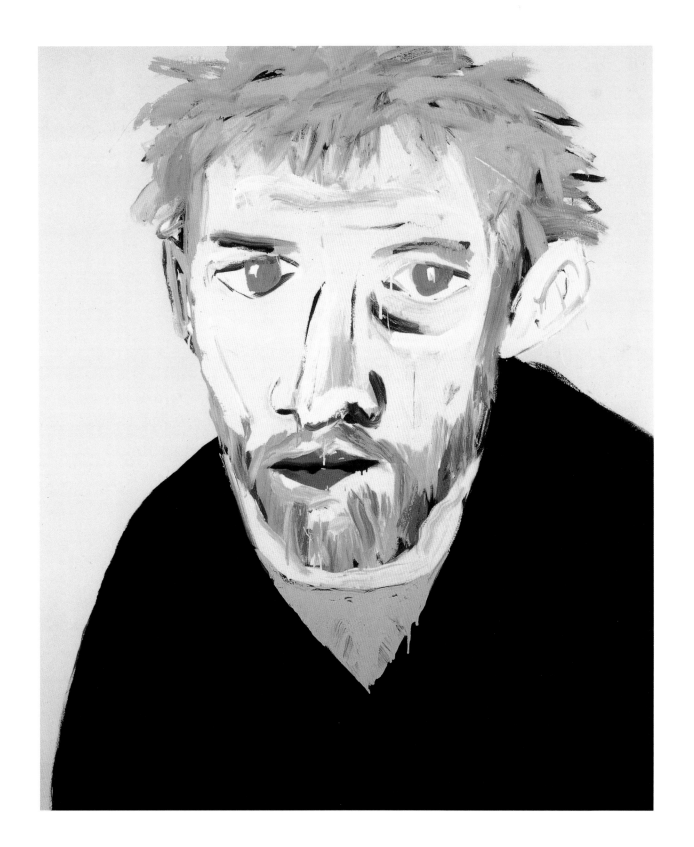

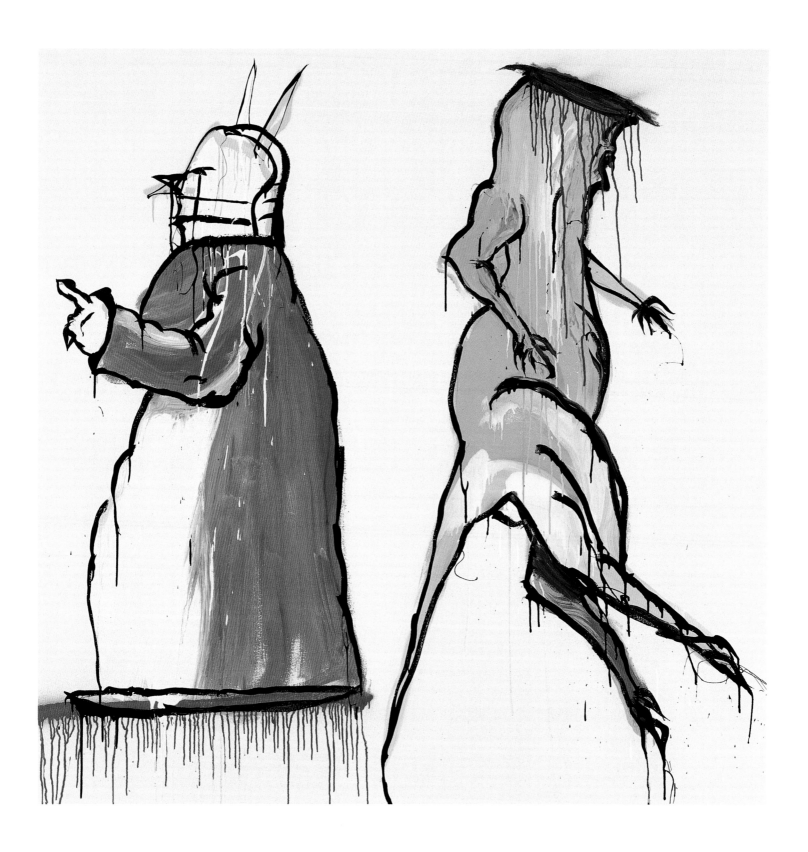

In these recent portraits, blindness is a metaphor for something withheld, a gaze eternally denied. Whether this is a residue of an authentic self or just the gap between persona and performance isn't clear. In *CELEBRITY II* (2000), Cullen exploits an early sweep of drippy paint by tilting the canvas on its side so that the paint now runs sideways, suggesting a windswept quality to the figure who is bandaged with a red swath across her face. Here, celebrity seems a kind of concealment or bloody mask that blinds both the wearer and the observer to whatever is underneath.

Cullen is keenly aware of the dynamics of role-playing and persona. He comes from a family of actors, most famously second-cousin Max, but finds the theatrical enterprise personally distasteful. (The artist's own gig as a stand-up comic was very brief.) 'I've always been suspicious of actors', he says. 'I suppose that's why I often paint people involved in some sort of act. You can reduce them quickly, or you can undress them fast. Every time I see my cousin Max on stage I think, at the end of the show, he's still acting. I want to say "Stop acting Max".'

Metaphorically, a lot of Cullen's paintings strip off the performer's rug – Cullen himself is bald – in an effort to stop the show. It's not a question of him revealing any truth behind the performance. Cullen understands that any measure of identity, including his own as an artist, involves a huge element of self-presentation. See here Cullen's 2002 self-portrait as Frida Kahlo, worked-up on the cover of an art kit designed to help children learn about contemporary art's icons, which shows Adam/Frida bald and stubbled, with piercing blue eyes, extra pouty lips, and sporting a swastika above the famous eyebrow. Coy, knowing, and menacing in a caricatured fashion, Frida's obsessive self-regard is transformed into the vaguely sexy stare of a football thug. Put this way, Cullen's types are less portraits of failure than different styles of self-presentation. Among the crooners, boxers, clowns, popes, floozies, fools, and laconic Australian men that populate his paintings, the artist finds himself at home.

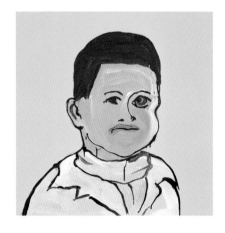

THE GOOD CHILD 2003
acrylic on canvas
122 x 122 cm
Private Collection

ART IS PALLIATIVE CARE

Cullen likes to say that art is a form of palliative care and, in this vein, his work aims to 'help' by holding on to attention. Art doesn't make things better, it just makes them bearable and in art, as in life, Cullen values endurance over beauty because, as he

Facing page:
HAPPINESS (WHERE ARE YOU) 2002
ink, enamel and acrylic on canvas
183 x 183 cm

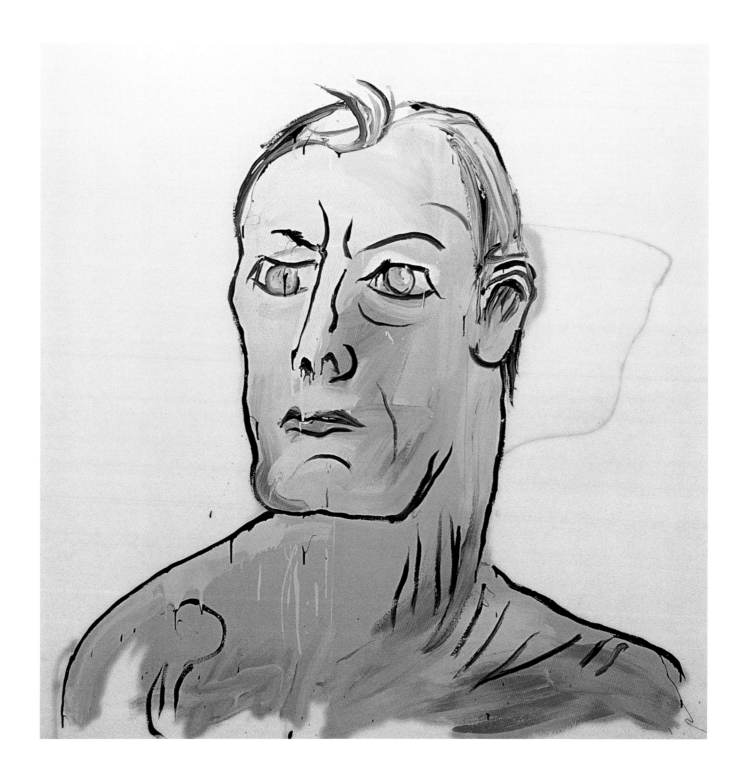

puts it, 'endurance is more important than truth'. In an artist's statement written for a group exhibition of work influenced by glam rock and heavy metal, Cullen compared his work to hard-core punk: 'What I really identify with in hard-core punk is that it obliterates self-reflection, and that's what I aim for in my own work ... Punk doesn't try to discover the truth about our inner psychological states. Just like my art, punk has more modest aims, it's temporary pain relief ... Good art shows how it is and so did punk ... the problems of art can be solved in a suburban bedroom'.[14]

In this view, art isn't a vehicle for self-expression. The self is not made manifest on the canvas, if anything something quite the opposite happens; making the work, the self is forgotten, suspended, blacked and blanked out. If there is an analogy with music here it isn't with rock and roll's libidinal release, but with a deliberately downscale head-banging obliteration. The claims made for Cullen's realism – by himself, and by many critics – follow easily if what he makes isn't governed by artistic interiority. Cullen has written that most of the text he uses comes from American hard-core punk magazines, TV and women's magazines.[15] This is a good strategy for bracketing his authorial presence while bolstering the claim of realism. Cullen simply uses what's out there, and what's out there, further downplaying any reference to subjectivity, he likes to call 'information'.

Critics have interpreted his idea of palliative care as well as his work's realism a little differently and despite all his denial of claims to self-expression, Cullen is often very much present in others' writing about his work where the objects on the floor or the wall are sometimes read as an index of the artist and his mental state. Cullen helps in this. He likes the photographer, and editors like his throwaway lines.

Jeff Gibson saw Cullen's intoxication reference in *COSMOLOGICAL MOTHER*'s amended beer keg as indicative of a lot of grunge work per se and symptomatic of its 'drunken logic'.[16] Drinking references punctuated critical essays as well as newspaper accounts of Cullen's work, while his particular brand of drunken logic seemed to inspire a corresponding thirst in writers. Catharine Lumby, writing on *LIFE FITNESS (SOPHISTICA-TED NAGGING)* (1995–96), a pair of brand new Daihatsu Centros Cullen had filled with clean, empty Tooheys Dry bottles, not only advised viewers that this was a work 'best viewed drunk', she suggested the most appropriate means of doing so. Christopher Chapman included a list of different beer brands in a homage to Cullen's own graphic

Facing page:
HEAD OF A DELUDED MAN 2003
acrylic on canvas
183 x 183 cm

Following pages:
LIFE FITNESS (SOPHISTICATED NAGGING) 1995–96
cars, beer bottles
dimensions variable
installation, Artspace, Sydney

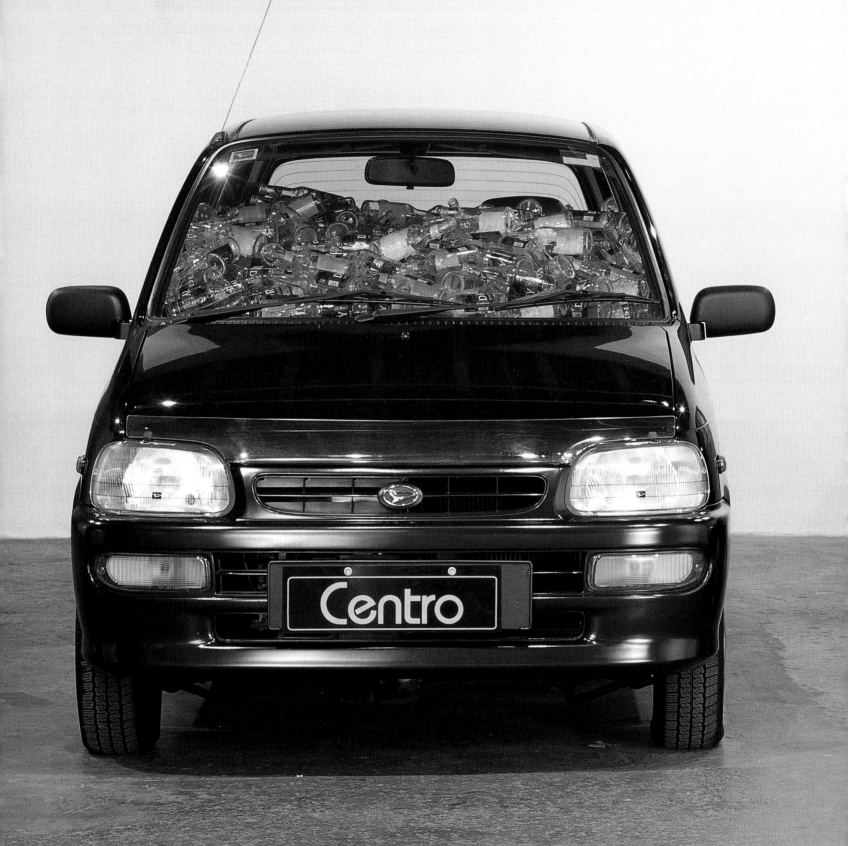

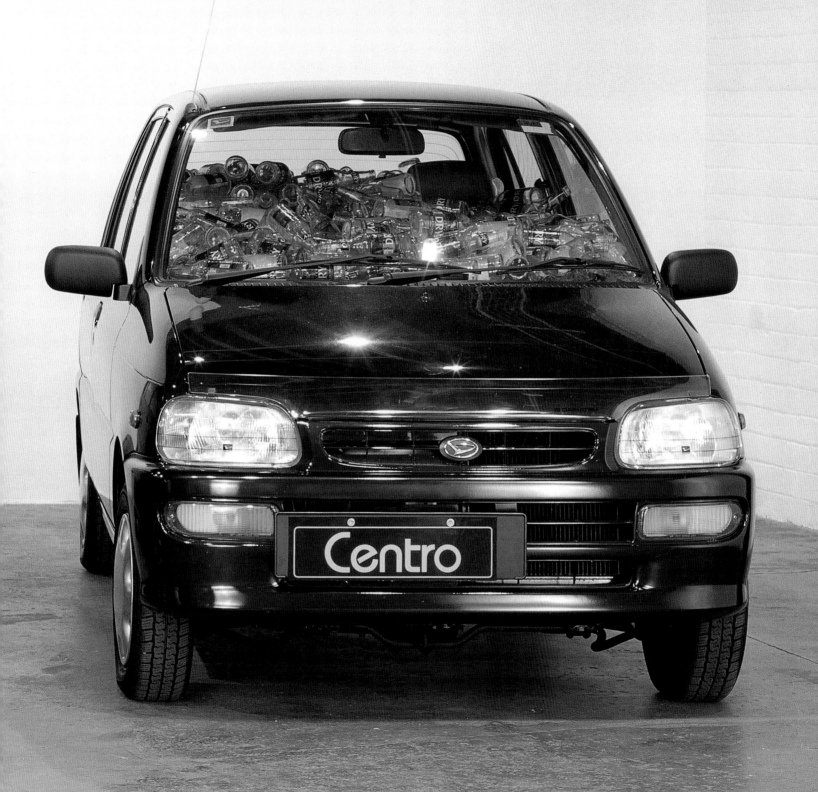

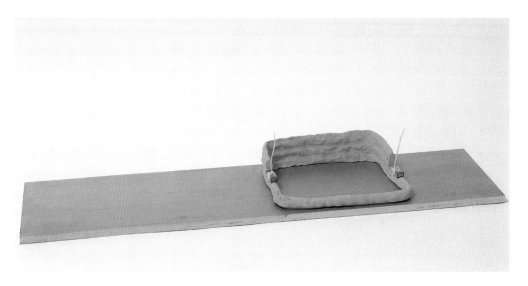

list-making in an essay for the artist's *Touch and Go* exhibition at the Art Gallery of New South Wales in 2000. And Bruce James acknowledged he was writing under the influence in his 'extended, stream-of-consciousness' essay for Cullen's *Blindside* exhibition in 1999.[17] Along with writers Colin Hood and Andrew Frost, the critical tune seemed to be 'I Love to Have a Beer with Adam'.

In some cases this recourse to drinking references reads like an effort to reproduce in prose the same effect as Cullen's work. Drinking clearly has a place here. Besides *COSMOLOGICAL MOTHER*, *LIFE FITNESS*, and the text painting *MY HEAD IS A CAR FULL OF EMPTY BEER BOTTLES*, Cullen has also produced *SPECIAL LITE NUDE*, showing a dolphin embryo cross crowned with a six-pack – he calls it a portrait of the Australian male, 'king of the drunks' – and *TOILET TRAINING* (2003), which depicts a fish-net-stockinged lush on the loo with 'Lorn to Booze' emblazoned on a nearby bottle. However when otherwise sober-minded criticism starts to read like the lost weekend, perhaps it's criticism that has trouble with the work. Catharine Lumby recognised the problem Cullen set for writers: 'Most of the art at the end of the 20th century is merely overdesigned, overdetermined and overprotected by critical babble. And this is the real subject of Cullen's work'.[18]

It isn't so much that Cullen tries to ward off criticism, although this could appear to be what he was doing when in an artist's statement for his first post-grunge show in

1994 he wrote: 'To undress these works or to engage in reflection or analysis would be a futile and dessicated projection'. Rather, his work resists easy critical categorisation and one of the ways it has done this is through its inept appearance. This look of failure was, if anything, more difficult to categorise after the moment of grunge than during it. Carrie Lumby, commenting on *Class*, Cullen's next show that featured ceramics, drawings on institutional stationery, and some early painting, put it like this: 'Cullen in this exhibition has managed to make interpretation itself look dyslexic'.[19]

Not every writer took the lameness of his post-grunge objects as a challenge to criticism. Felicity Fenner saw the 1994 exhibition of ceramics installed on the floor firmly within the ambit of abjection, albeit with a 'comfortable homeliness', a 'considered optimism' and an 'inherent determination to "work" as objects'.[20] *PROOF OF ALIEN INVOLVEMENT IN THE EGYPTIAN PYRAMIDS*, shown at this time, comprised a terracotta vessel, hand-formed by Cullen, with two biro antennae attached, sitting on a board on the floor. While the title signalled Cullen's interest in outmoded occult fantasies and the work's construction suggested a distant bodily reference, it was the artist's reparative gesture in affixing the biro attachments that linked this work to his nostrums about his practice generally. Cullen repeated this gesture in similar works, some of which had plastic ties, cloth handles or erasers affixed to them, and called it 'remedially apprehending' the objects. He likened it to the graphic additions he made to printed remedial educational materials, *EPISODE 1–5* (1994), also shown at this time which he described as 'helping to help the helped'.

Cullen's remedial impulse is bred for failure. It needs failure to take effect, for who else but the failed need this help? At the same time, Cullen's remedial actions do not improve anything. *MINORITY GROUP* and *GOODY GOODY* (both 1995), each six units of ceramic vessels with attached calico handles, some of which look like ears, seem entirely undone by his 'fixing'. Benjamin Genocchio called them 'clumsy, almost remedial' and wrote that they were 'confounding interpretation' by refusing to be either functional objects or Minimal art.[21] By being between categories, Cullen's work, as Genocchio spells out, stops up the critical imperative to maintain distinctions.

In spite of critics' problems categorising Cullen's work, realism remains an agreed-upon term. It's one that Cullen claims for himself. He describes his work as 'extreme realism', but adds he'd like another title soon. Even in the earliest exhibited installments,

PROOF OF ALIEN INVOLVEMENT IN THE EGYPTIAN PYRAMIDS (2) 1994
adhesive tape, various plastics, terracotta, enamel board
dimensions variable
Collection: Art Gallery of New South Wales

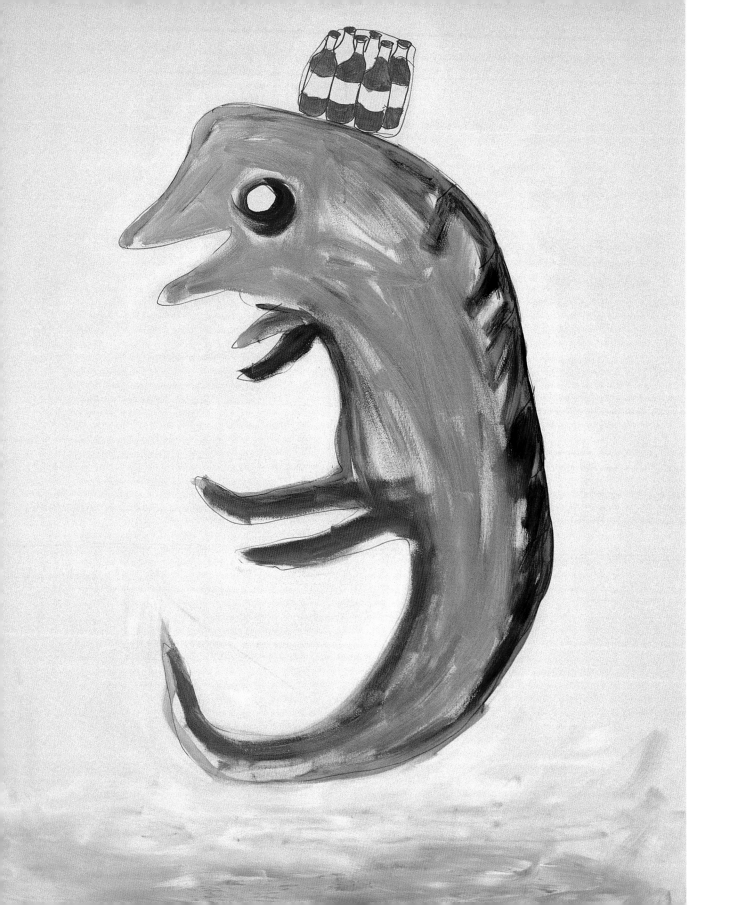

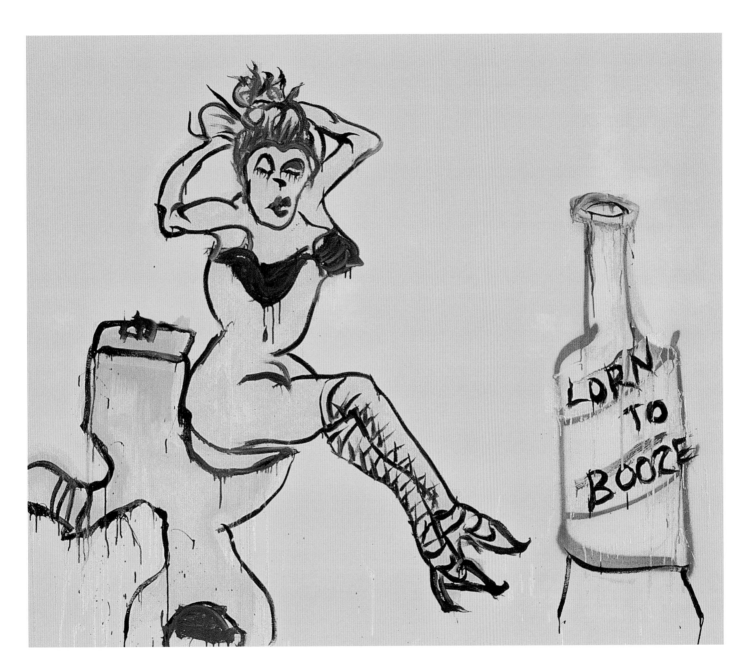

Facing page:
SPECIAL LITE NUDE 1996
acrylic on canvas
130 x 100 cm

TOILET TRAINING 2003
acrylic on canvas
183 x 213 cm

critics imputed a realist potential. Jeff Gibson wrote of Cullen's Newtown grunge scene, '... these artworks provide idiosyncratic indices to the underbelly of the moral majority'.[22] Looking at the *World Fantasy* exhibition a few years later, Bruce James called the graffiti-laden surfaces of paintings like *WARM MAMMARY WAR* (1993) a visual regurgitation of 'the memories of a single day, or maybe a $1.20 bus ride', and called the work 'sharp-edged mirror shards' reflecting the audience's world.[23] If Cullen were holding up a mirror, what he showed was ugly: 'All the untethered fragments of our quietly imploding culture', was Sebastian Smee's assessment.[24] And viewers outside Australia saw the same. Tessa Laird, reviewing Cullen's *Amateur Exorcist* exhibition in Dunedin, saw in the candy-bar dreamings, headless kangaroos and other mangled icons of Australia 'not the tropes of a naughty boy spraying obscenities on the wall. They are sentiments and images as deep and twisted as society's ills themselves'.[25]

More recently, the realist view has taken on a softer edge: 'deep and twisted', yes, but with compassion, too. Lara Travis has argued that because of its unstinting realism, Cullen's work demands viewers change their attitudes toward his themes of 'violence, stupidity, desperation and hopelessness. Inevitably, and daggy though it sounds', she wrote, 'it's likely to be with compassion and understanding'.[25] Suggesting this transformation comes about when viewers recognise themselves in Cullen's trawlings of our common moral cesspit, she risks taking Cullen's reparative and palliative impulses all too literally, but Travis is not alone in this revision. In the exhibition *Bittersweet*, curator Wayne Tunnicliffe included Cullen among a group of new humanist artists whose work was located 'somewhere between irony and belief', and whose effect Bruce James called one of 'delayed melancholy', pointing however distantly to an expressed desire for some better place, somewhere else.[27]

This desire for another place, 'for other worlds and better possibilities', is precisely what Trevor Smith sees in Cullen's fondness for aliens, crooners and movie stars. By mixing 'the intimate with public spectacle,' he writes, 'Cullen's paintings embody a desire to find some corner of the world where ethics are not just a smokescreen for hidden betrayals and private brutality'.[28] And for Andrew Frost, Cullen is a moralist who disguises his utopianism by adopting the guise of a 'bitter romantic realist'.[29]

It's not always possible to see this in any particular painting, but a work like *SHUT UP, NOBODY WANTS TO HEAR YOUR STORIES*, which Cullen acknowledges is a portrait

Facing page:

(left)
MINORITY GROUP 1995
porcelain and calico
6 units, each 24 x 20 cm

(right)
GOODY GOODY 1995
ceramic and ink
6 units, each 24 x 20 cm

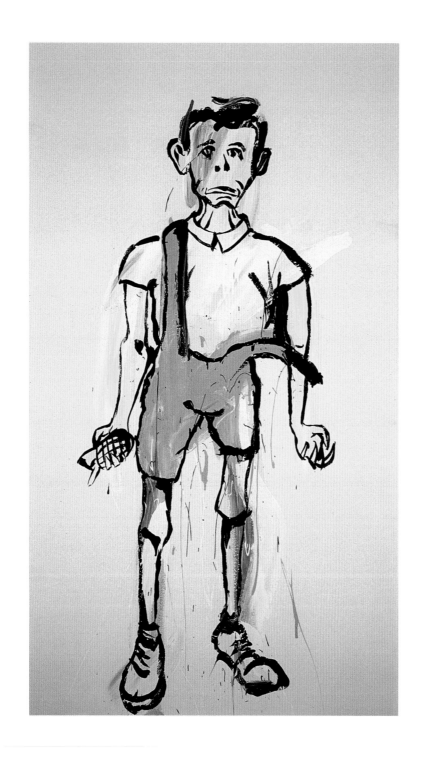

DEAD WOMEN DON'T SAY NO 2001
acrylic on canvas
122 x 213 cm
Private Collection

Facing page:
OUR SAVIOUR 2003
acrylic on canvas
183 x 183 cm

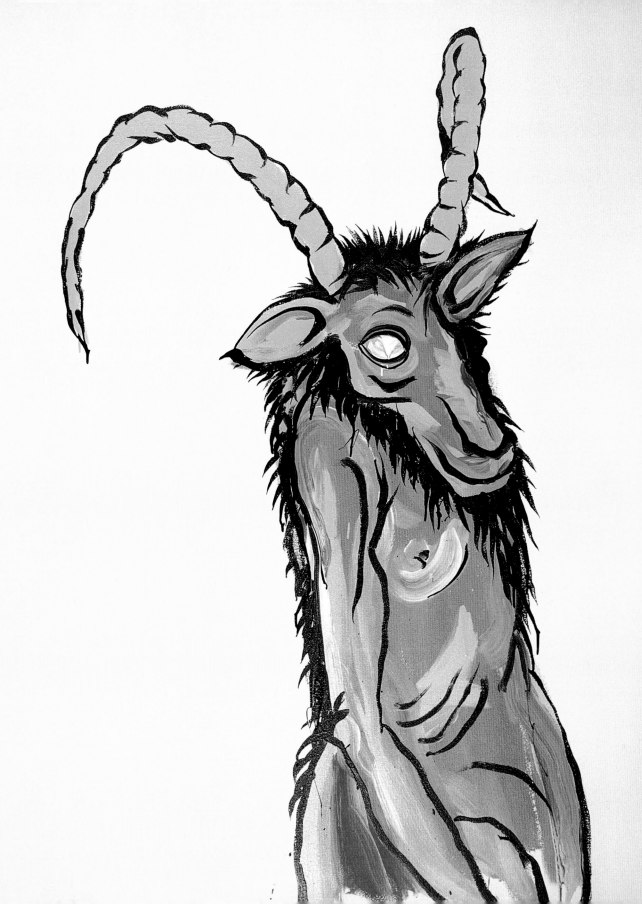

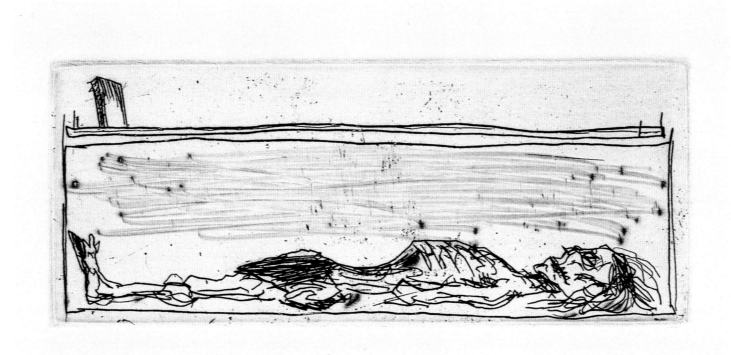

CHRIST 2001
etching on paper
30 x 23 cm

of his parents, manages to touch as well as shock. The pronouncements about art's role as palliative care could seem like more provocation – how could images like Cullen's offer anything in the way of relief – up until his involvement with *Anita and Beyond*, an exhibition about the 1986 rape and murder of Sydney nurse Anita Coby that was pitched firmly within a therapeutic framework of community healing and closure. His portraits of the five murderers, worked up in lurid colours from police mug shots, suggested a measure of compassion for them, for in Cullen's eyes they too were victims, men now 'in hell' is how he put it at the time.

Art can't do much against rape and murder. A paintbrush isn't a knife or a gun, as Cullen readily admits. Eschewing any attempt at psychological insight, Cullen's portraits of these ordinary-looking young men refuse to categorise them as simply and exclusively evil. This is real human failure, and it seems light years away from the abject theatrics of installments like *STIFF* and *COSMOLOGICAL MOTHER*.

Cullen's recent work suggests maturity. There is a greater ease with his subject matter, the technique is accomplished. His edginess remains in small portraits of bush pigs, and in paintings like *DEAD WOMEN DON'T SAY NO* (2001), a funny/scary take on Diane Arbus's famous image of a young boy and a toy grenade, and *OUR SAVIOUR* (2003), a coy satyr suggesting both the Lamb of God and John the Baptist.

An unexhibited group of landscapes from 2003, stripped of the dislocated individuals typical of his work, were disturbingly beautiful. But it's Cullen's etchings that surprise the most. Forced to work more slowly and on a smaller scale, Cullen has honed his repertoire of marks with quiet assurance. The quality of line is recognisably his, but now it carries with it the cultural resonance of the print-maker's craft rather than the doodler's frustration or the graffiti writer's urban anomie. *CHRIST* (2001), a skeleton in a box with a headstone, seems honest in its doubt rather than irreverent; *STILLBORN*, a headless quadruped with human attributes, revisits abjection theory and the post-human fascination with corporeal boundaries; and *REPUBLICAN* gives three shots of Ned Kelly, in a portrait, armoured-up, and dead. In each of these too there is a sense of art historical knowledge lightly worn, a departure from the visual wash of the everyday that has characterised many of his paintings. 'Come up and see my etchings' is of course a bad comedian's line, but it's not Cullen the prankster whom these works invoke. It's Cullen, just hitting his prime.

Footnotes:

1 Bob Ellis, *The Ellis-Leak Almanac 2000 AD*, Pluto Press, Sydney, 2001; Catharine Lumby, 'Seeing double', *Life Fitness (Sophisticated Nagging)*, Artspace, Sydney, 1997.

2 Christopher Chapman, 'Zero to thirty-two in twenty minutes', *Touch and Go*, Art Gallery of New South Wales, Sydney, 1998.

3 Christopher Chapman, 'Zero to thirty-two in twenty minutes', *Touch and Go*, Art Gallery of New South Wales, Sydney, 1998.

4 Catharine Lumby, 'Adam Cullen: the ready-made saboteur', *World Art*, no. 1, 1993, p. 36.

5 Julia Kristeva, *Powers of Horror: an Essay on Abjection*, trans. Leon S. Roudiez, Columbia University Press, New York, 1982, p. 4.

6 Rosalind Krauss, 'Conclusion, the destiny of the "informe"' in Yve-Alain Bois & Rosalind E Krauss', *Formless: a User's Guide*, Zone Books, New York, 1997, p. 238.

7 Asher B Edelman, Zdenek Felix, Ida Gianelli & Dakis Joannou, 'Introduction', in Jeffrey Deitch, *Post-Human*, DAP, New York, 1992.

8 Cullen was included in all but the last of these exhibitions.

9 Jeff Gibson, 'Avant-grunge', *Art & Text*, no. 45, 1993, p. 25.

10 Adam Cullen, 'Birth of an idiot, or where I would have got if I'd been stupid', MFA thesis, College of Fine Arts, University of New South Wales, 1998, p. 11.

11 Cullen quoted by Catharine Lumby, 'Seachange at the Archibald', *The Bulletin*, 28 March 2000, p. 103.

12 Bruce James, 'Finding diamonds in the rough', *Sydney Morning Herald*, 31 July 1999, p. 12.

13 Andrew Frost, 'The reverse of chickens', *Adam Cullen: Value*, Australian Centre for Contemporary Art, Melbourne, 2000.

14 Adam Cullen, cited by Lara Travis, *None More Blacker*, 200 Gertrude Street, Melbourne, 2001.

15 Adam Cullen, 'Birth of an idiot, or where I would have got if I'd been stupid', MFA thesis, College of Fine Arts, University of New South Wales, 1998, p. 24.

16 Jeff Gibson, 'Avant-grunge', *Art & Text*, no. 45, 1993, p. 24.

17 Bruce James, 'Finding diamonds in the rough', *Sydney Morning Herald*, 31 July 1999, p. 12.

18 Catharine Lumby, 'Seeing double', *Life Fitness (Sophisticated Nagging)*, Artspace, Sydney, 1997.

19 Carrie Lumby, 'Adam Cullen: class', *Eyeline*, no. 28, 1996, p. 43.

20 Felicity Fenner, 'A genre beyond grunge', *Sydney Morning Herald*, 27 May 1994.

21 Benjamin Genocchio, 'Miserabilism: the art of Adam Cullen', *Eyeline*, no. 29, 1995, p. 15.

22 Jeff Gibson, 'Avant-grunge', *Art & Text*, no. 45, 1993, p. 25.

23 Bruce James, 'Bad, banal and unabashed', *Sydney Morning Herald*, 13 May 1993.

24 Sebastian Smee, 'Goodness grievance', *Sydney Morning Herald*, 6 May 2000.

25 Tessa Laird, 'Professional killer', *Broadsheet*, vol. 27, no. 4, 1998.

26 Lara Travis, 'Bad form', *Future Dirt*, Contemporary Art Centre of South Australia, Adelaide, 2003.

27 Wayne Tunnicliffe, *Bittersweet*, Art Gallery of New South Wales, Sydney, 2002, p. 14; Bruce James, 'Mind the banana skin, but enjoy the aftertaste', *Sydney Morning Herald*, 8 May 2002, p. 17.

28 Trevor Smith, 'Adam Cullen', *25th Bienal De Sao Paulo*, Iconografias Metropolitanas Cidades, pp. 276–7.

29 Andrew Frost, private correspondence with the author, November 2003.

Facing page:
THE GOING DOWN OF THE SUN 2002
ink, enamel and acrylic on canvas
183 x 183 cm

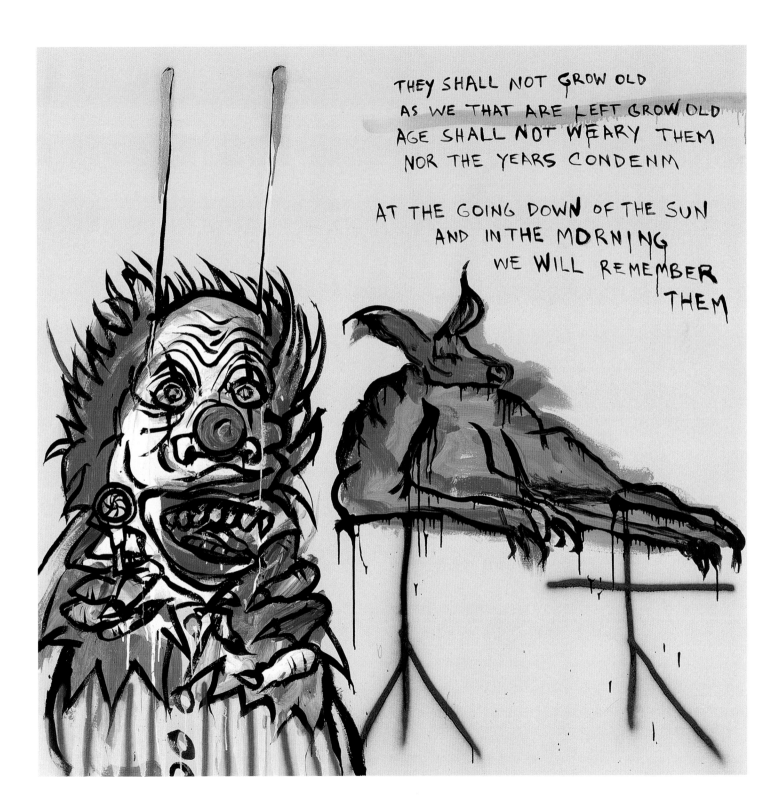

THEY SHALL NOT GROW OLD
AS WE THAT ARE LEFT GROW OLD
AGE SHALL NOT WEARY THEM
NOR THE YEARS CONDENM

AT THE GOING DOWN OF THE SUN
AND IN THE MORNING
WE WILL REMEMBER
THEM

NEW PROGRESS WITH GOOD THINGS (1) 1994
adhesive tape, various plastics, terracotta, enamel board
variable dimensions
Collection: Art Gallery of New South Wales

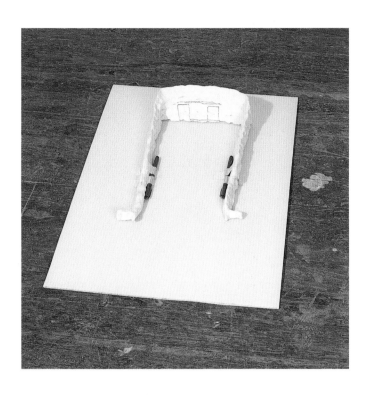
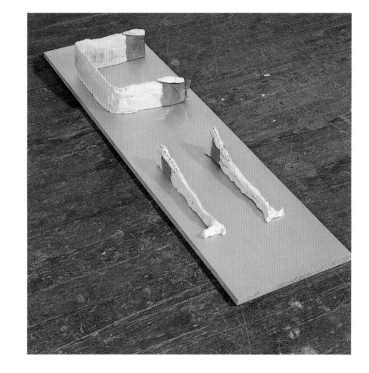

NEW PROGRESS WITH GOOD THINGS (2) and *(3)* 1994
adhesive tape, various plastics, terracotta, enamel board
variable dimensions
Collection: Art Gallery of New South Wales

BEETHOVEN, SUMMERTIME 1995
acrylic on canvas.
2 panels each 61 x 61cm

SOMEONE STARTED TWISTING 1995
ink on paper
125 x 90 cm

CLOWN BABY 1996
ink on canvas
diptych, each panel 122 x 92 cm
Private Collection

I ONLY THINK ABOUT YOU WHEN I'M DRUNK 1996
ink, enamel, cardboard and adhesive
dimensions variable

SIDE PART 1996
ink on canvas
137 x 153 cm
Private Collection

MALE VIRGIN 1996
ink on canvas
137 x 153 cm
Private Collection

Facing page:
EXPERTISE COMPLETION CALL 1996
enamel and ink on canvas
200 x 150 cm

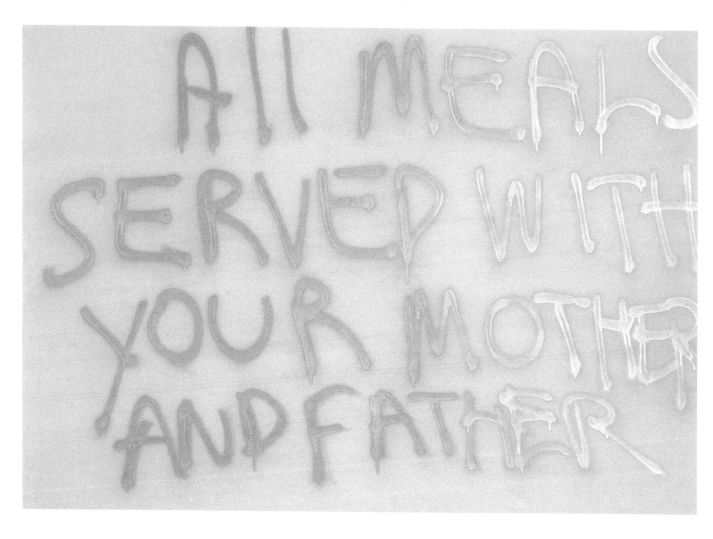

ALL MEALS SERVED WITH YOUR MOTHER & FATHER 1996
acrylic on canvas
100 x 130 cm

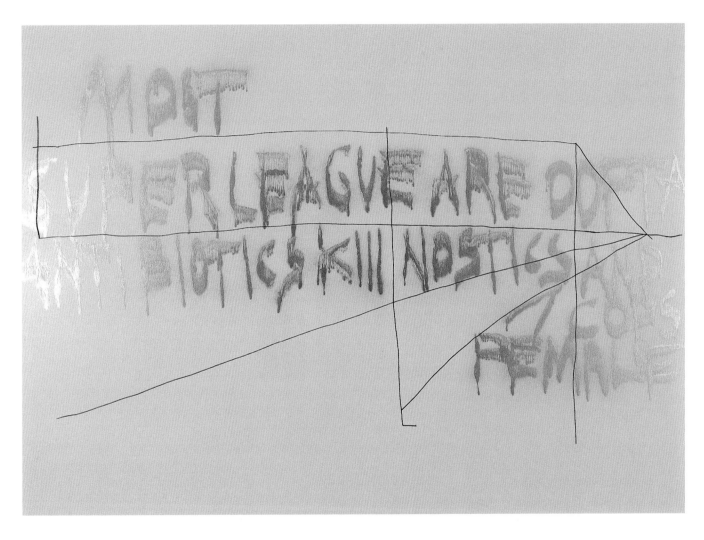

MOST SUPER LEAGUE ARE OOFTA. ANTIBIOTICS KILL GNOSTICS AND FEMALE COPS 1997
enamel and ink on canvas
213 x 152 cm

Left:
PATHOLOGYOLOGY 1997
acrylic and enamel on plaster
approx 30 x 15 x 20 cm

Facing page:
DON'T POINT YOU'LL POKE HOLES IN THE
AIR AND SUFFOCATE THE FAIRIES 1997
acrylic and enamel on plaster
approx 50 x 15 x 10 cm

Above:
GRANVILLE ABDUCTION 1997
acrylic and enamel on plaster
approx. 35 x 20 x 15 cm

Facing page
I SAW MYSELF IN THE NUDE AND
I'M REALLY ANGRY 1997
acrylic and enamel on plaster
approx. 35 x 25 x 20 cm

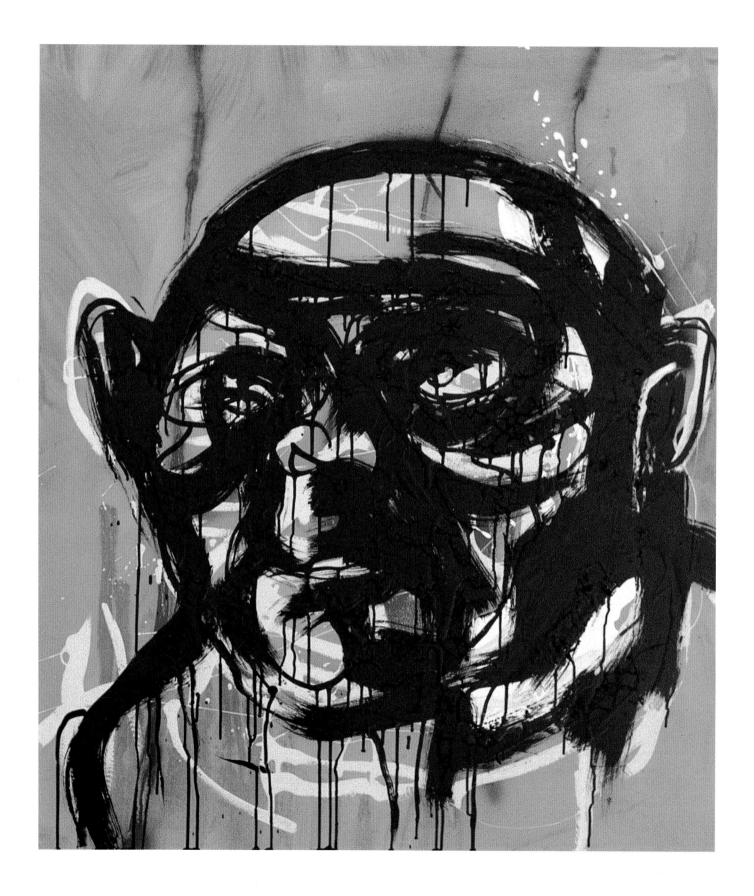

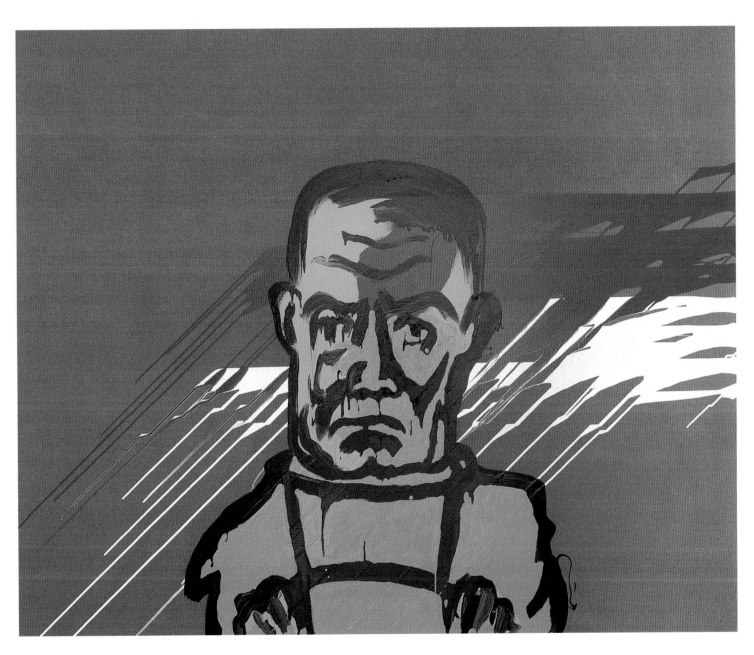

Facing page:
AUSTRALIAN SAINT (8) CHIMP 1999
enamel on board
81 x 71 cm
Collection: Artbank

BLINDSIDE 1999
enamel and acrylic on canvas
152 x 183 cm
Private Collection

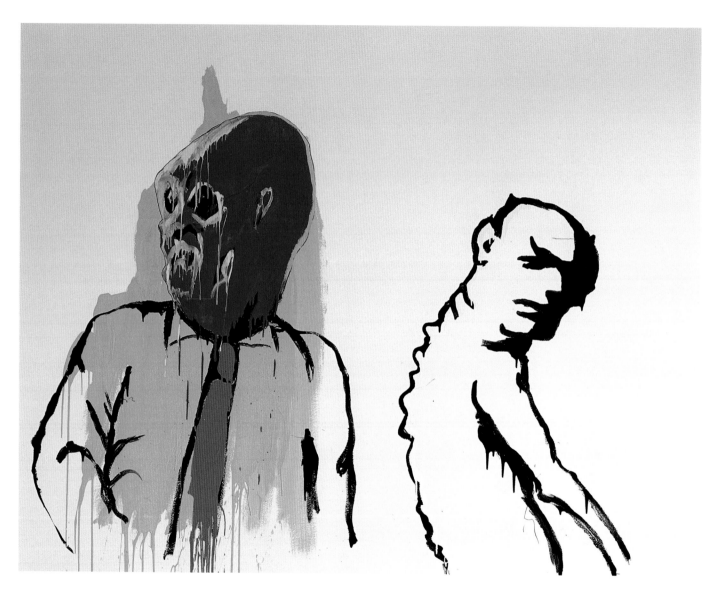

SMALL BUSINESS 1999
enamel and acrylic on canvas
167 x 214 cm
Collection: Art Gallery of Western Australia

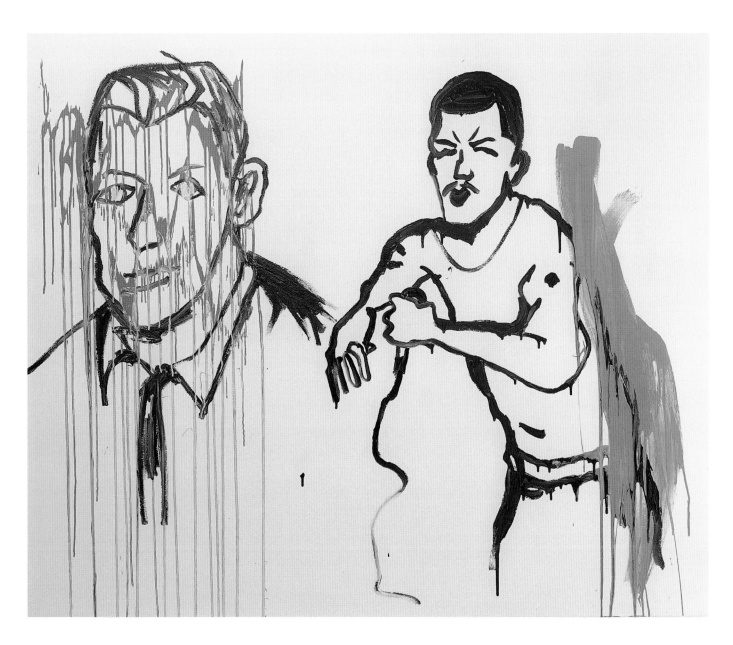

THIS AIN'T NO DISCO 1999
enamel and acrylic on canvas
152 x 183 cm
Private Collection

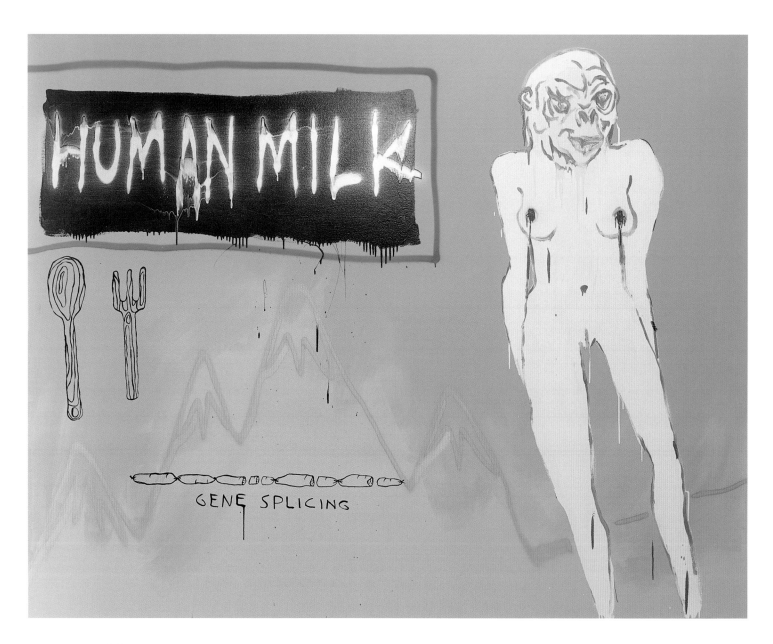

HUMAN MILK 1999
enamel and acrylic on canvas
167 x 211 cm
Collection: Art Gallery of South Australia

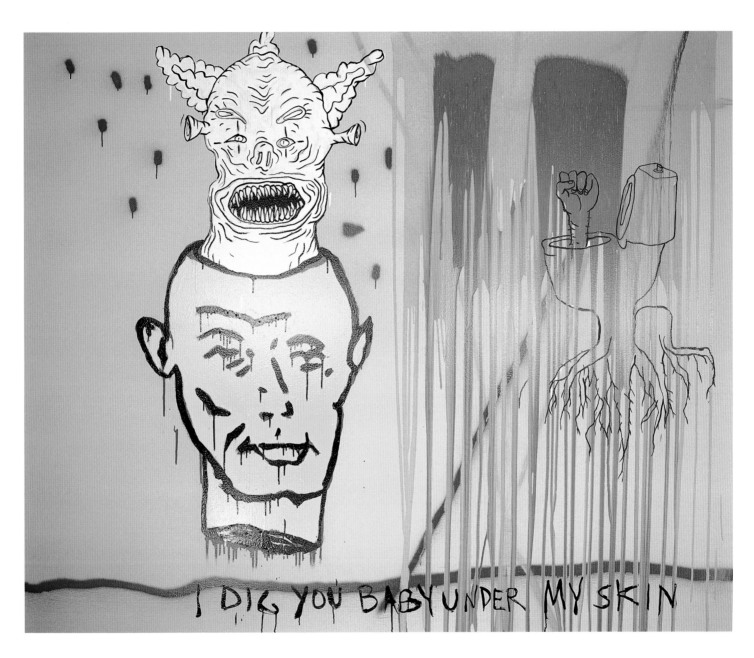

I DIG YOU BABY UNDER MY SKIN 1999
enamel and acrylic on canvas
152 x 183 cm
Collection: Monash University Gallery

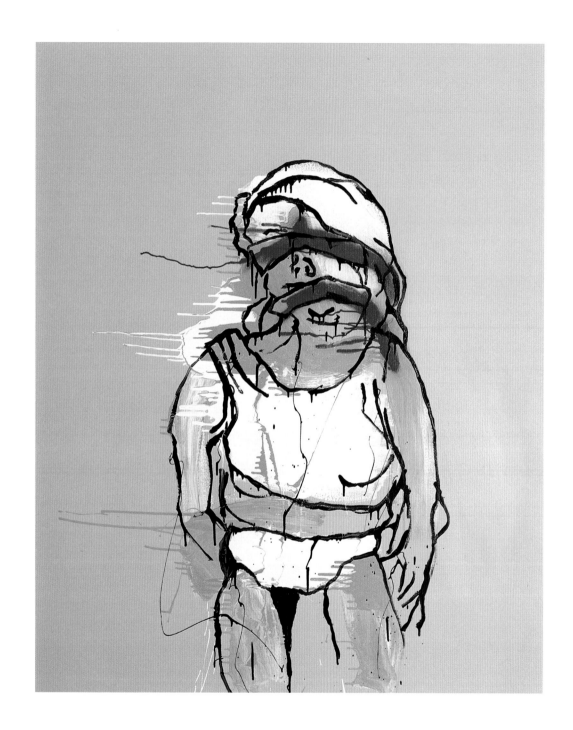

Left:
SPECIAL CELEBRITY II 2000
acrylic on canvas
152 x 122 cm
Private Collection

Facing page:
*SHARING HORIZONS THAT
ARE NEW TO US* 2000
enamel and acrylic on canvas
183 x 153 cm
Collection: Monash University Gallery

BEDTIME TV 2000
acrylic on canvas
152 x 213 cm
Private Collection

INTERPERSONAL 2000
enamel and acrylic on canvas
152 x 183 cm
Private Collection

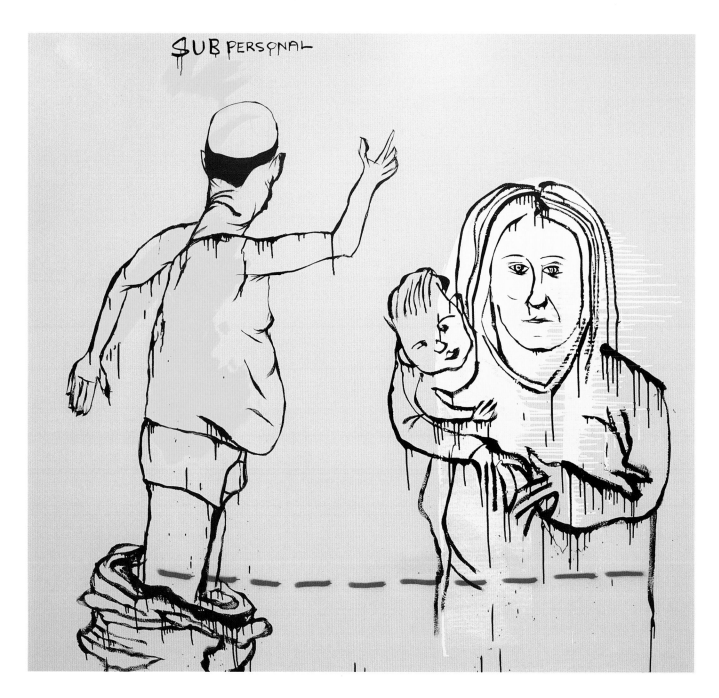

SUBPERSONAL 2000
acrylic on canvas
198 x 213 cm

THE HOUSE IN MY HEAD 2000
acrylic on canvas
168 x 183 cm

FESTIVE CATHARSIS 2000
ink, enamel and acrylic on canvas
115 x 178 cm
Private Collection

COMEDIC RELIEF 2000
acrylic on canvas
152 x 213 cm

LIVE 2000
acrylic on canvas
168 x 213 cm
Private Collection

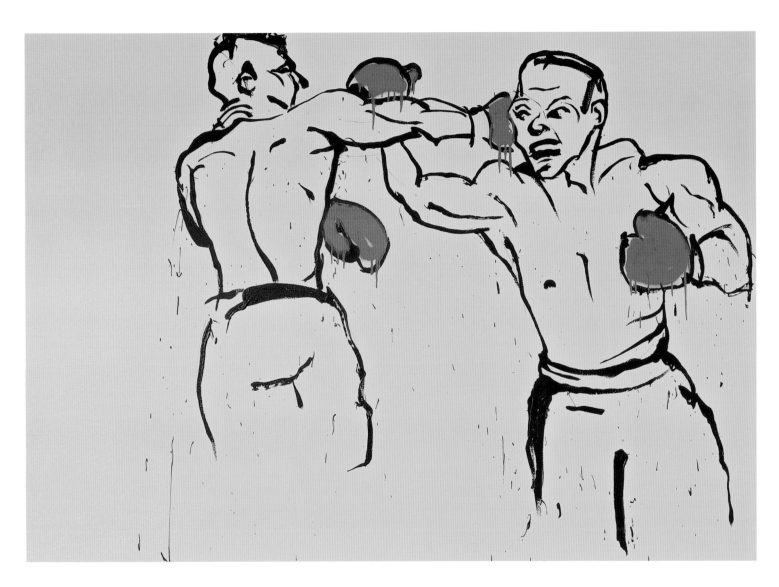

FINDING WAYS TO FORGIVE YOURSELF 2001
ink, enamel and acrylic on canvas
153 x 213 cm
Private Collection

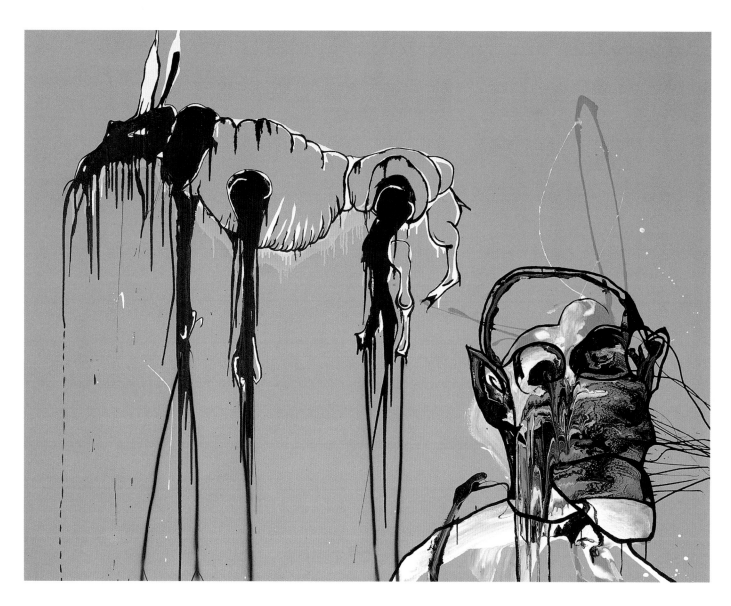

REVERSE REBIRTHING 2001
ink, enamel and acrylic on canvas
157 x 210 cm
Private Collection

Facing page:
SATAN YOUR KINGDOM MUST COME DOWN 2001
ink, enamel and acrylic on canvas
167.5 x 198.5 cm
Private Collection

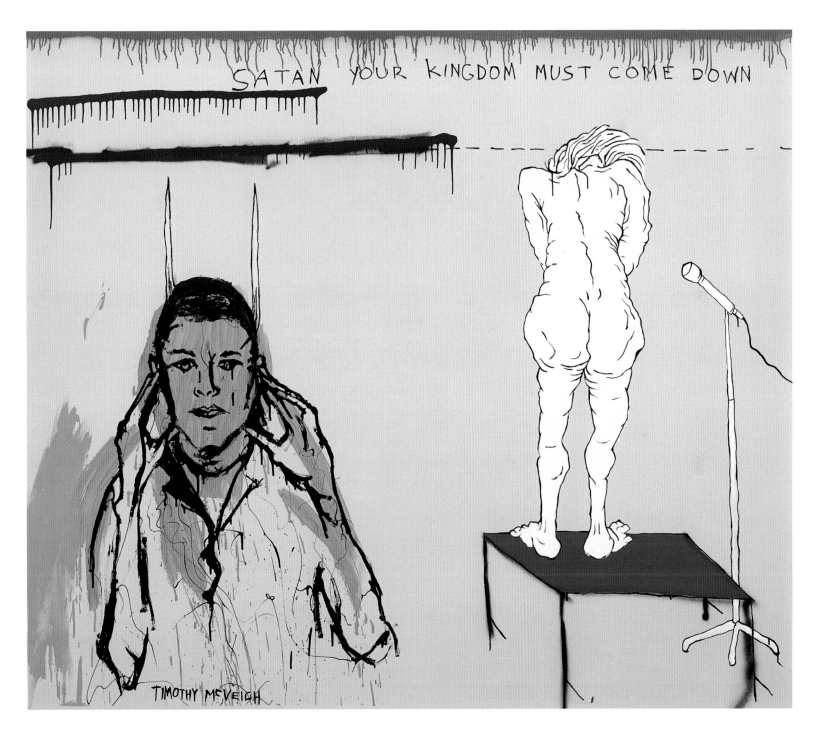

PLAYTIME 2003
acrylic on canvas
183 x 183 cm

Facing page:
SMOKING MAN 2001
ink and acrylic on canvas
122 x 91.5 cm
Private Collection

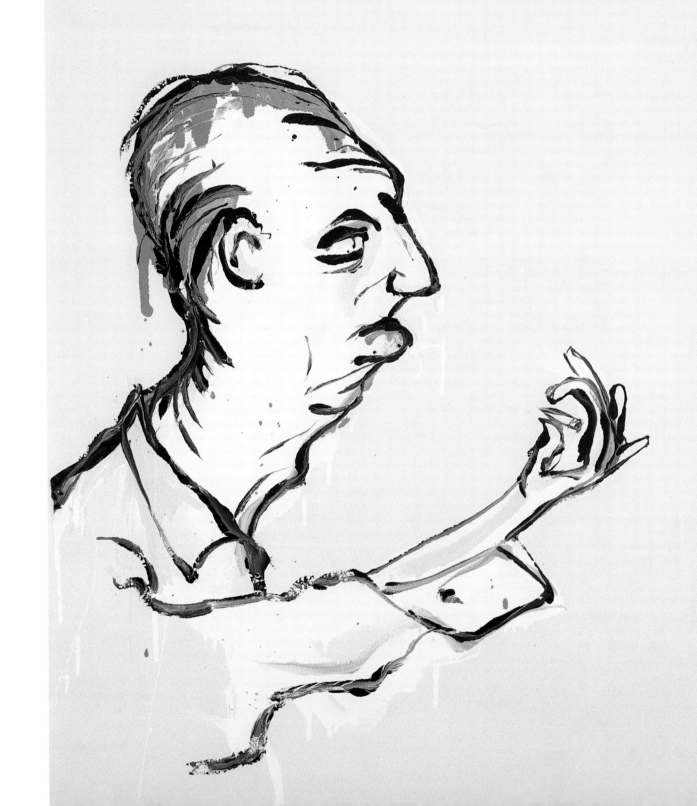

ANXIETY NOTATION 2002
acrylic on canvas
152.5 x 213.5 cm

Facing page:
WE CAN BE HEROES 2002
ink, enamel and acrylic on canvas
183 x 230 cm

INFANTICIDE 2002
ink, enamel and acrylic on canvas
153 x 183 cm

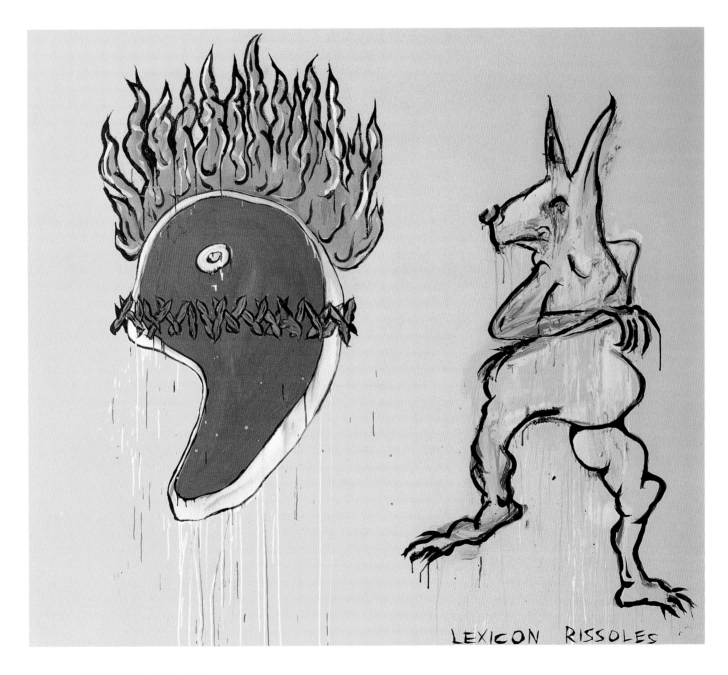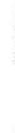

CORPUS CHRISTI KANGAROO 2003
acrylic on canvas
244 x 244 cm

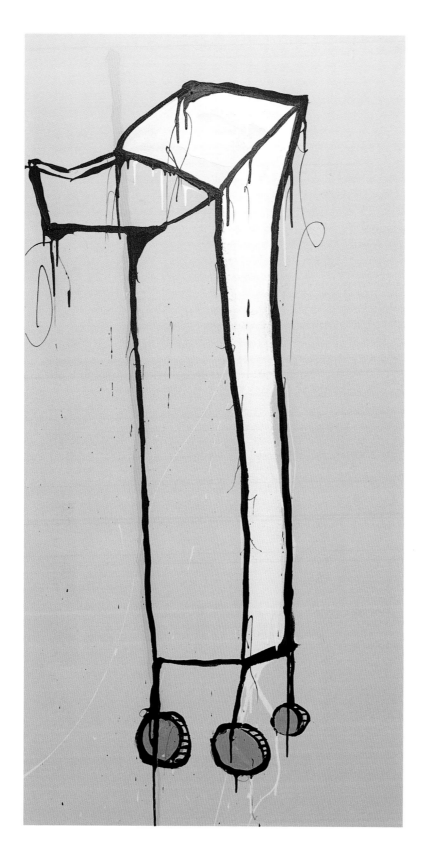

Left:
SPECIAL NEW BED 2002
enamel and acrylic on canvas
183 x 91 cm
Private Collection

Facing page:
A TOWN OF FEAR 2002
ink, enamel and acrylic on canvas
182.5 x 212.5 cm
Collection: Artbank

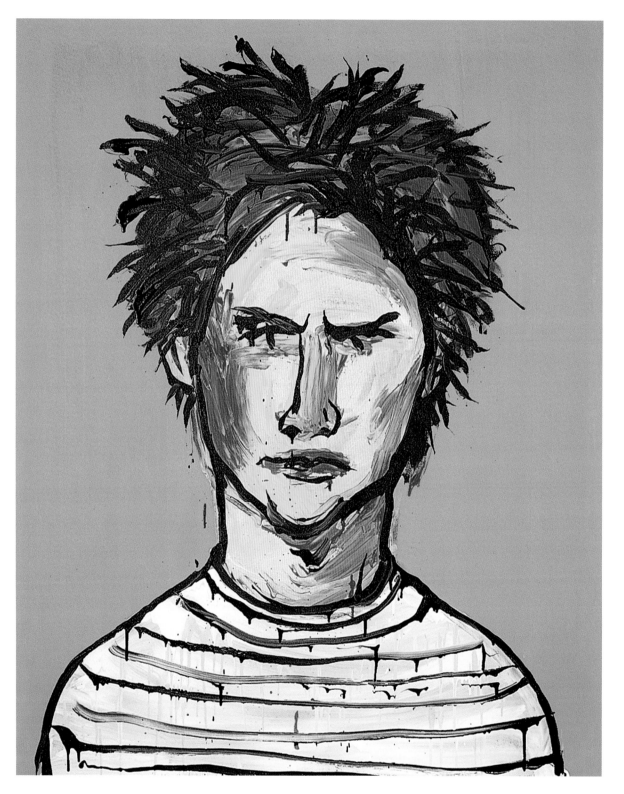

Facing page:

(top left)
MICHAEL MURDOCH 2003
acrylic on canvas
152.5 x 121.5 cm

(top right)
GARY MURPHY 2003
acrylic on canvas
152.5 x 121.5 cm

(bottom left)
MICHAEL MURPHY 2003
acrylic on canvas
152.5 x 121.5 cm

(bottom right)
LES MURPHY 2003
acrylic on canvas
152.5 x 121.5 cm

Left:
JOHN TRAVERS 2003
acrylic on canvas
152.5 x 121.5 cm

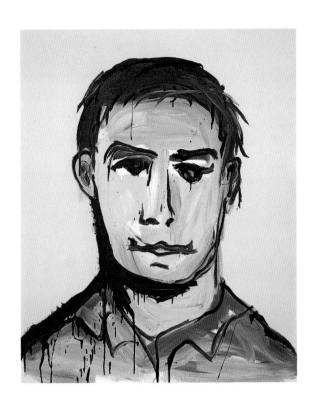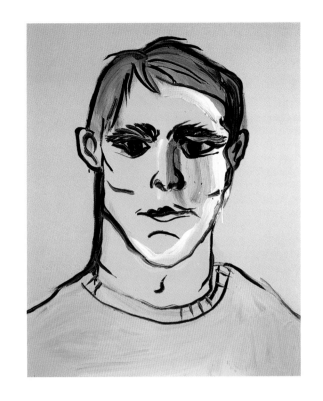
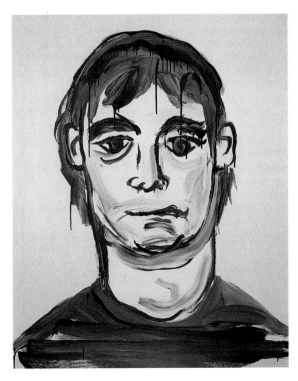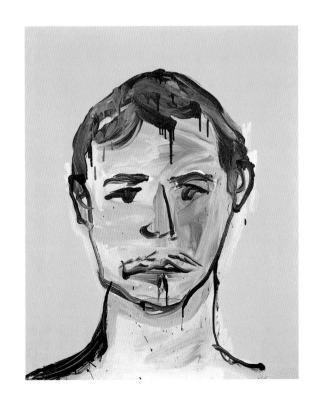

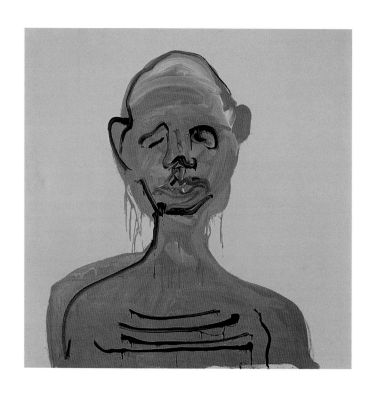

TOURIST 2003
acrylic on canvas
183 x 183 cm

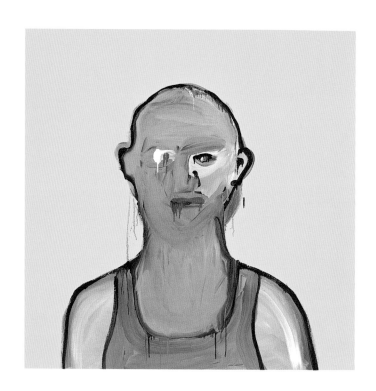

MAN IN SINGLET 2003
acrylic on canvas
152 x 152 cm

Facing page:
I WISH I WAS BENNY HILL (TROUBLE & SQUALOR) 2004
acrylic on canvas
183.5 x 152.5 cm

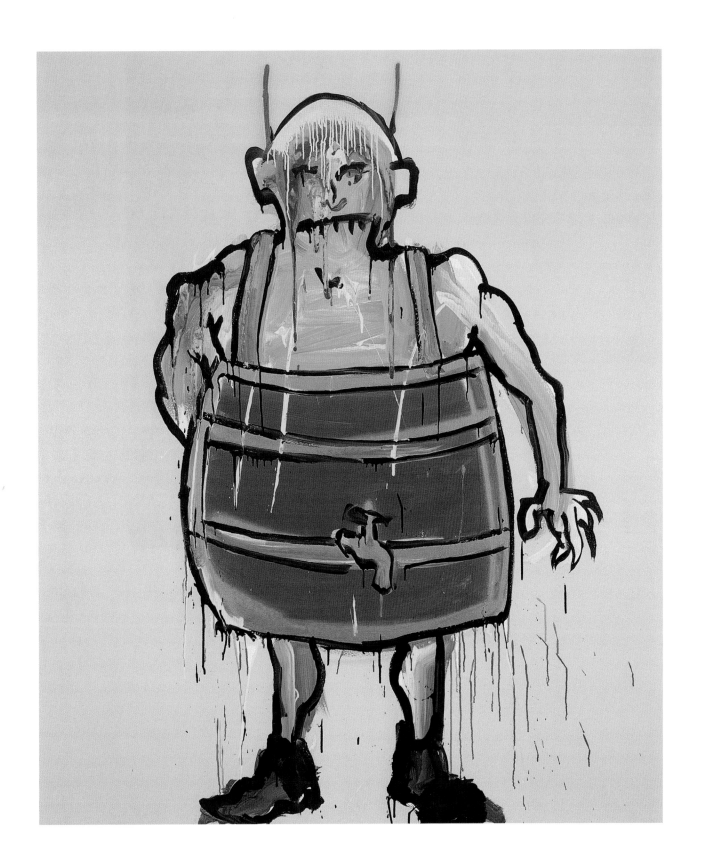

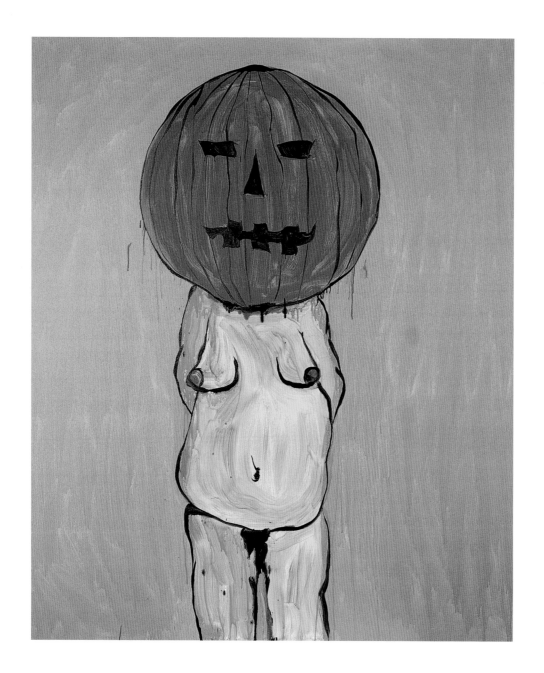

Left:
WHEN SHE GOES, I DRESS UP 2003
acrylic on canvas
183 x 152 cm

Facing page:
*NEW SOUTH WELSHMAN
(UNCLE ROY)* 2003
acrylic on canvas
183 x 183 cm
Private Collection

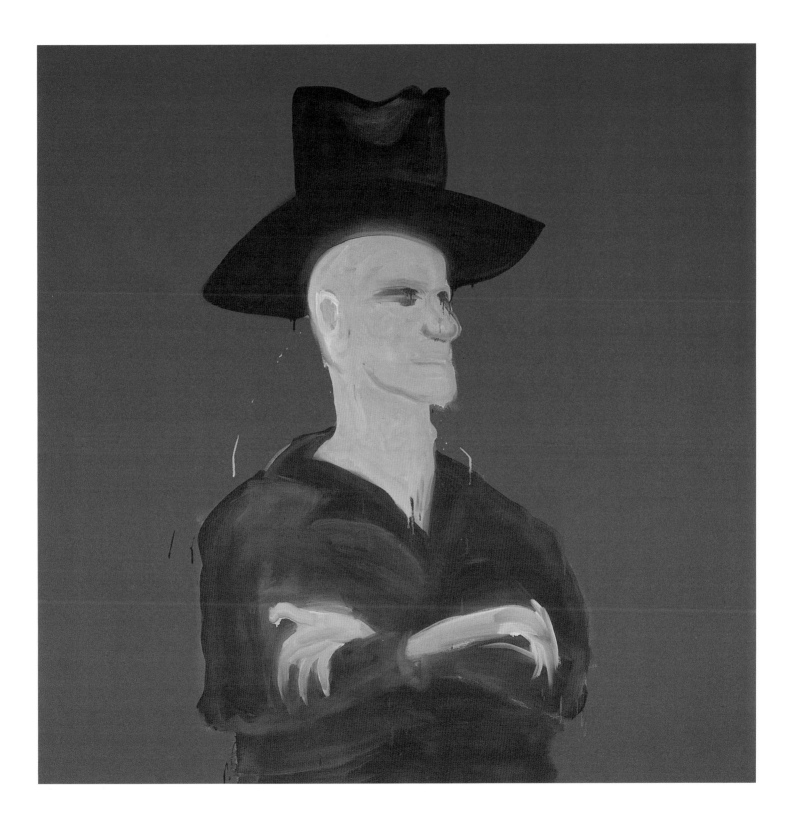

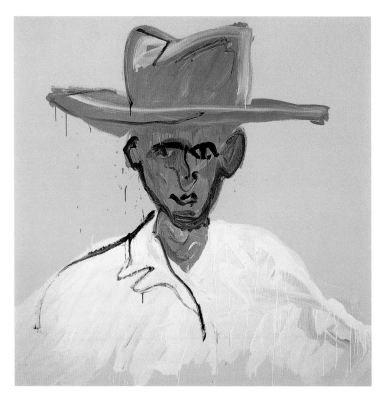

OLD JOB – NEW AUSTRALIAN 2003
acrylic on canvas
183 x 183 cm

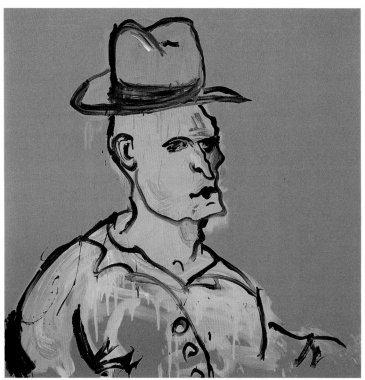

WINDMILL CONTRACTOR 2003
acrylic on canvas
183 x 183 cm

Facing page:
TWO MEN 2003
acrylic on canvas
183 x 183 cm
Private Collection

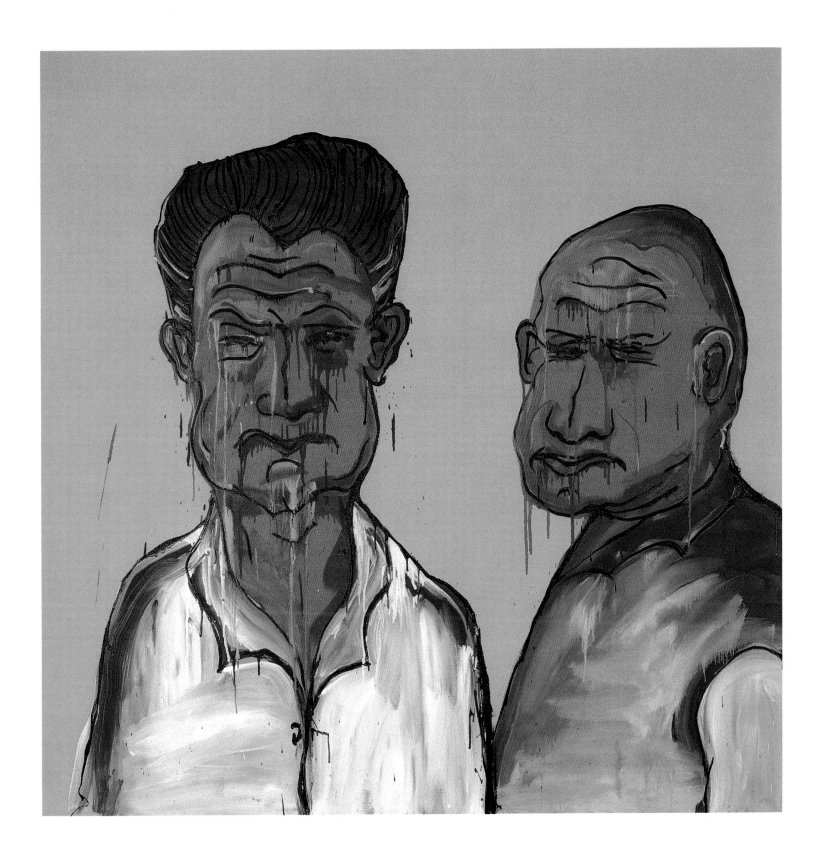

CURRICULUM VITAE

Born 1965, Australia, currently lives and works in Sydney

Education

1999 Master of Fine Arts (UNSW)
1987 Diploma of Professional Art Studies (City Art Institute)
1986 Bachelor of Fine Arts (City Art Institute)

Selected Individual Exhibitions

2004 'Our Place in the Pacific', Cairns City Gallery; Toowoomba Regional Gallery
2003 'Our Place in the Pacific', Newcastle Regional Gallery; Gold Coast City Gallery
 'Future Dirt', Contemporary Art Centre of SA
 'Far and Away', Yuill/Crowley, Sydney
2002 'UNAUSTRALIAN', Yuill/Crowley, Sydney
2001 'Night and Day', Yuill/Crowley, Sydney
 'The Placebo Effect', Artspace, Sydney
2000 'Value', ACCA, Melbourne
 'Miss Gin Gin Showgirl' (with Dale Frank), Hazelhurst Regional Gallery
 'Interpersonal', Yuill/Crowley, Sydney
1999 'Blind Side', Experimental Art Foundation, Adelaide, Institute of Modern Art, Brisbane
 'Hotel/Motel', Yuill/Crowley, Sydney
 'Genuine Imitation', First Floor, Melbourne
1998 'Amateur Exorcist', Dunedin Public Art Gallery, Dunedin
 'Self-Loving', Fiat Lux, Auckland
 'Touch and Go', Level 2 Project, Art Gallery of NSW, Sydney
 'World Fantasy', Yuill/Crowley, Sydney
1997 'Special', Yuill/Crowley, Sydney
 'I Only Think About You When I'm Drunk', Test Strip, Auckland
 'Life Fitness', Art Space, Sydney
1996 'The Australian Labour Party', Yuill/Crowley, Sydney
 'Live Rock', CBD Gallery, Sydney
1995 'Class', Yuill/Crowley, Sydney
 'Peace is Cool', CBD Gallery, Sydney
1994 'Soft Material Facts', Yuill/Crowley, Sydney
 'Special Galore Type', 200 Gertrude Street, Melbourne
 'Homoerotic', CBD Gallery, Sydney
1993 'Software', Selenium Gallery, Sydney
 'August', CBD Gallery, Sydney
 'Lucifer' (with Matthys Gerber), Yuill/Crowley, Sydney
 'Heterocampstick', Black Gallery, Sydney

Selected Group Exhibitions

2004 'The Meaning of Everything', Yuill/Crowley, Sydney
 'The Archibald Prize', Art Gallery of NSW, Sydney
 'The Sulman Prize', Art Gallery of NSW, Sydney
2003 'Six Degrees of Separation', Yuill/Crowley, Sydney

'Foxed', Yuill/Crowley, Sydney
'The Archibald Prize', Art Gallery of NSW, Sydney
'Anita and Beyond', Penrith Regional Gallery
2002　'Group Exhibition', Yuill/Crowley, Sydney
'Group Exhibition', Yuill/Crowley, Sydney
'The Archibald Prize', Art Gallery of NSW, Sydney
'Kedumba Drawing Prize', Kedumba Gallery, NSW
'Bitter Sweet', The Art Gallery of NSW, Sydney
25th Bienal de Sao Paulo 'Iconografias Metropolitanas', Sao Paulo
'Group Exhibition', Yuill/Crowley, Sydney
2001　'Portraits 2001 – An Australian Odessey', Tweed River Regional Art Gallery
'None More Blacker', 200 Gertrude Street, Melbourne
'Group Exhibition', Yuill/Crowley, Sydney
'Painting: an arcane technology', Ian Potter Museum of Art, University of Melbourne
2000　'Art in the World 2000', Pont Alexandre III, Paris
'Video Salon, Week of Art and New Media', Brussels
'Not Quite Right', Grey Matter Gallery, Sydney
'Blind', Yuill/Crowley, Sydney
'The Archibald Prize', Art Gallery of NSW, Sydney
1999　'Sick and Dizzy, Asia-Pacific Triennial of Contemporary Art', State Library, Brisbane
'Preambles', Perspecta, Museum of Contemporary Art, Sydney
'Smoke', Sherman Galleries ArtBox, Sydney
'Sequence', Yuill/Crowley, Sydney
'Passive', South, Sydney
'The Archibald Prize', Art Gallery of NSW, Sydney
'Group Exhibition', Yuill/Crowley, Sydney
'Persuasive Humours', Mosman Art Gallery, Sydney
'Salon des Refuses', S.H. Ervin Art Gallery, Sydney
'Same Old, Same Old', Yuill/Crowley, Sydney
'Australian Perspecta 1999 – Living Here Now/Art And Politics – Preambles', Museum of
Contemporary Art, Sydney
1998　'Rubick 2: Science Fiction', publication curated by Ricky Swallow
'Mondo Cane', Herringbone Gallery, Sydney
'Underbelly', various commercial premises, Adelaide
'Incognito', Yuill/Crowley, Sydney
'Graphic', Monash University Gallery, Melbourne
'Rough Trade', Plimsoll Gallery, University of Tasmania
1997　'A Taste in Art', Community Aid Abroad, Sotheby's Auction
'Components', Yuill/Crowley, Sydney
'Rough Trade', TANKS, Cairns
'Art Rage', Sydney Intermedia Network, Art Gallery of NSW, Sydney
'Ambient (Male) Identity', Contemporary Art Centre of SA, Adelaide
'Queer Crossings', Ivan Dougherty Gallery, Sydney
'Evil Art', Side On Gallery, Sydney
'Group Exhibition', Yuill/Crowley, Sydney
1996　'Sweet & Sticky', Bundaberg Arts Centre
'White Hysteria', Contemporary Art Centre of South Australia
'View of the New', new acquisitions, National Gallery of Australia, Canberra

COCKTAIL GIRL AND BLIND DATE　2002
acrylic on canvas
183 x 183 cm

'Adelaide Biennial of Australian Art', Art Gallery of South Australia

1995 'All You Need', Yuill/Crowley, Sydney
 'Decadence', 200 Gertrude Street, Melbourne
 'Fluxibelstructures', Kunsthaus Oerlikon, Zurich
 'Anthology', Art Space, Sydney

1994 '600,000 Hours', Experimental Art Foundation, Adelaide
 'Five', Yuill/Crowley, Sydney
 'Poltergeist 3', Canberra School of Art, Canberra

1993 'Unfair', Cologne
 'Perspecta', Art Gallery of NSW, Sydney
 'Scrounge Time', Plimsoll Gallery, School of Art, University of Tasmania, Hobart
 'Residence No. 4 and No. 1', Newtown, Sydney
 'Shirthead', Mori Gallery, Sydney
 'Death', Ivan Dougherty Gallery, Sydney
 'Rad Scunge', Karyn Lovegrove Gallery, Melbourne

1992 'Signals', Museum of Contemporary Art, Sydney
 'Supermart', Blaxland Gallery, Melbourne
 'Jeune Peinture', Grand Pallais, Paris

Selected Bibliography

2004 Barker, Clare, 'The Art of Shock and Horror', *Poster*, no. 4, Summer 2004
 Lalor, Peter, 'Bold Run For the Archies', *The Australian*, March 19 2004
 Morgan, Joyce, 'Enter At Your Own Risk', *Sydney Morning Herald*, March 6-7 2004
 Periz, Ingrid, 'Pup, Your Mouth's Too Big For Your Boots', *Art & Australia*, vol. 41 Autumn 2004

2003 Frost, Andrew, 'Our Place In the Pacific', (cat. essay) 'I'm No Picasso But', 2003
 Kubler, Alison, 'Our Place In the Pacific', (cat. essay), 2003
 Loxley, Anne, 'Far And Away', *Sydney Morning Herald*, 19 February 2003
 Martin-Chew, Louise, 'Slap In the Darkness', *The Australian*, 7 July 2003
 Morgan, Joyce, 'Artists Put Human Face Of Tragedy In New Light', *Sydney Morning Herald*, 3 March 2003
 Travers, Lara, 'Future Dirt', (cat. essay) 'Bad Form', 2003

2002 Crawford, Ashley, 'Chopper for Children', *Black + White*, no. 60, April 2002
 Crawford, Ashley, 'ARCO', (cat. essay), Madrid, Spain 2002
 Frost, Andrew, 'Painting 101', *Australian Style*, no. 59, February 2002
 Frost, Andrew, 'Proudly UnAustralian', (cat. essay), June 2002
 Frost, Andrew, 'The Collectible', *HQ*, no. 95, 2002
 Geczy, Adam, 'Crypto-realism, Bittersweet: Contemporary Australian Art at the Art Gallery of New South Wales', *Art Monthly*, no. 151, July 2002
 Gennocchio, Benjamin, 'Twitchy Escapist Impulses', *The Weekend Australian*, 4 May 2002
 Huxley, John, 'Murder He Wrote', *The Sydney Morning Herald*, 1 May 2002
 James, Bruce, 'Mind the banana skin, but enjoy the aftertaste', *The Sydney Morning Herald*, 8 May 2002
 Smith, Trevor, '25th Biennale de Sao Paolo' (cat. essay), Brazil, March 2002
 Spencer, Matther, and Tedmanson, Sophie, 'Sun Won't Go Down on Elton Art Spree', *The Weekend Australian*, 27 April 2002
 Tunnicliffe, Wayne, 'Bitter Sweet', (cat. essay), The Art Gallery of NSW, 19 April 2002
 Tunnicliffe, Wayne, 'Art That Bites', *Look*, April 2002

2001 Hutak, Michael, 'Little Chop of Horrors', *The Bulletin*, 12 June 2001

LANDSCAPE 2003
etching on paper
61 x 80 cm

Barclay, Alison, 'New Coat of Colour', *The Herald Sun*, 23 March 2001

Nelson, Robert, 'Canvassing a Theory of Painting', *The Sunday Age*, 18 February 2001

Nelson, Robert, 'Mock Shock' review, *The Age*, 10 March 2001

Reid, Chris, 'Painting: Reinvigorating the Arcane', *RealTime*, April-May 2001

Ross, Peter, *Let's Face It, The History of the Archibald Prize*, published by The Art Gallery of NSW 2001

Sexton Jennifer, 'Chopper's jail-cell fairytale a comfort for the bullied', *The Australian*, 7-8 July 2001

Strickland, Katrina and Holgate, Ben, 'Art Angel', *The Weekend Australian*, 18-19 August 2001

Travis, Lara, 'Hot Prospects', *Vogue Australia*, February 2001

Travis, Lara, 'Paint it Black', *Australian Style*, May 2001

Travis, Lara, 'Chopper's grim fable', *The Age*, 8 June 2001

Travis, Lara, 'None More Blacker' (cat. essay), 200 Gertrude St, Melbourne 2001

2000 Burke, Kelly, 'Size Does Matter in this Annual Art Horse Race', *The Sydney Morning Herald*, March 2000

Clifford, Cristen, 'Adam and Evil', *Black + White*, no. 47, November 2000

Frost, Andrew, 'Francisco Goya, Rolf Harris and Adam Cullen', *Australian Style*, no. 42, August 2000

Frost, Andrew, 'The Reverse of Chickens', (cat. essay), ACCA, Melbourne, 2000

Frost, Andrew, 'Miss Gin Gin Junior Showgirl', (cat. essay), Hazelhurst Regional Gallery, 2000

Hallet, Bryce, 'A Portrait of the Artist as a Happy Man', *The Sydney Morning Herald*, 18 March 2000

Hampson, Jane, 'Brush with Fame', *The Sydney Morning Herald*, 12 March 2000

James, Bruce, 'Archie's Sea Change', *The Sydney Morning Herald*, 18 March 2000

James, Bruce, 'Of Torsos and Tears', *The Sydney Morning Herald*, 1 January 2000

Lake, Tim, 'A Couple of Local Boys', *The Glebe*, 22 March 2000

Lumby, Catharine, 'Sea Change at the Archibald', *The Bulletin*, 28 March 2000

McCulloch-Uehlin, Susan, 'Diver Dan's Brush with Stardom', *The Weekend Australian*, 18 March 2000

Morris, Rachel, 'Our Top Artists', *The Daily Telegraph*, 6 January 2000

O'Conner, Kim, 'Two Share Archibald Limelight', *Inner Western Courier*, 27 March 2000

Sexton, Jennifer, 'Painter Finds There's More Than One Way to Skin a Cat', *The Australian*, 28 April 2000

Simmonds, Diana, 'Enough Canvas to Wrap Up a Gallery', *The Sunday Telegraph*, 19 March 2000

Smee, Sebastian, 'Goodness Grievance', *The Sydney Morning Herald*, 6 May 2000

Smee, Sebastian, 'A Reality Check at Hazelhurst', *The Sydney Morning Herald*, 1 July 2000

Smee, Sebastian, 'Visual Art', *The Sydney Morning Herald*, 28 December 2000

1999 Chapman, Christopher, 'Blind Side' (cat. essay), 1999

Cochrane, Peter, 'Challenging Self-Portrait Wins the Archibald', *The Sydney Morning Herald*, 20 March 1999

Gawronski, Alex, 'Adam Cullen', *Globe*, Summer 1999

Genocchio, Benjamin, 'Intoxicating Images Diverge from Grunge', *The Australian*, 6 August 1999

Holgate, Ben, 'And All It Took Was a Hole in the Head', *The Weekend Australian*, 20 March 1999

James, Bruce, 'So Nearly Out of the Ordinary', *The Sydney Morning Herald*, 20 March 1999

James, Bruce, 'Finding Diamonds in the Rough', *The Sydney Morning Herald*, 31 July 1999

James, Bruce, 'Goya to Toyota: April Fool's Day Lines', (cat. essay), 1999

LePetit, Paul, 'Fame in the Frame, *The Sunday Telegraph*', 14 March 1999

GAOL SEX 1999
acrylic on canvas
183 x 152 cm
Private Collection

Smee, Sebastian, 'The Ones to Watch on a Day at the Faces', *The Sydney Morning Herald*, 18 March 1999

1998 Chapman, Christopher, 'Touch and Go', (cat. essay), 1998

Chapman, Christopher, 'writing degree zero', *Log Illustrated*, no. 3 1998

Crane, Stephen, 'Touch and Go', *Like, Art Magazine*, no. 6 1998

Genocchio, Ben, 'Photography Beside Itself', *Photofile*, no. 55 1998

James, Bruce, 'Bad, Banal and Unabashed', *The Sydney Morning Herald*, 13 May 1998

Laird, Tessa, 'Professional Killer', *Broadsheet*, vol. 27, no. 4, Summer 1998

Porter, Gwynneth, 'Amateur Exorcist', (cat. essay) 'There goes the neighbourhood', 1998

Porter, Gwynneth, 'Under the Southern Cross', *Log Illustrated*, no. 4, 1998

Stanhope, Zara, 'Graphic', (cat. essay) 1998

Stapleton, John, 'Artist Drives Collectors to Abstraction', *The Australian*, 31 December 1998

1997 Chapman, Christopher, 'Abstract Identity', *Broadsheet*, vol. 26, no. 1, 1997

Curnow, Ben, 'Special', *Like, Art Magazine*, no. 3 May 1997

Frost, Andrew, 'Who is Adam Cullen?', *Australian Art Collector*, no. 3, December 1997

James, Bruce, review, *The Sydney Morning Herald*, 30 May 1997

James, Bruce, review, *The Sydney Morning Herald*, 28 November 1997

Hood, Colin, 'Special', *Eyeline*, no. 34, Spring 1997

Lumby, Catharine, 'Seeing Double – Life Fitness', (cat. essay), Artspace, 1997

Radok, Stephanie, 'Drugs'n'Art', *Artlink*, vol. 17, no. 2, 1997

1996 Colless, Edward, 'Adam Cullen', *The Error of My Ways*. Selected Writings (1981–1994), 1996

James, Bruce, review, *The Sydney Morning Herald*, 16 August 1996

James, Bruce, 'Chapman's Casper', *Art Monthly*, no. 88, April 1996

Radok, Stephanie, 'Shagged and Tagged', *The Adelaide Review*, March 1996

Schubert, Robert, '1996 Adelaide Biennial', *Flash Art*, Nov-Dec, 1996

Wark, McKenzie, 'Fun House', (cat. essay), Adelaide Biennial of Australian Art, 1996

Watson, Bronwyn, 'Schlock Tactics', *The Bulletin*, 16 April 1996

1995 Broker, D., '600,000 Hours', *Art + Text*, no. 50, 1995

Demetrius, Mark, 'Artists Crash Music Video', *Rolling Stone*, no. 509, May 1995

Fenner, Felicity, 'Seeing Beyond the Bickering of Art versus Craft', *The Sydney Morning Herald*, 31 March 1995

Genocchio, Ben, 'Miserabilism: The Art of Adam Cullen', *Eyeline*, no. 29, 1995

Lumby, Carrie, 'Adam Cullen: Class', *Eyeline*, vol. 28, Spring 1995

Neylon, John, 'Images of Death', *Artlink*, vol. 14, no. 4, 1995

Schubert, Robert, 'Warped Crotches and Phallic Prods', *RealTime*, no. 5, March 1995

1994 Chapman, Christopher, 'Conceptual Vertigo', *Midwest*, no. 6, 1994

Chapman, Christopher, 'Special Galore Type', (cat. essay), 200 Gertrude St, 1994

Fenner, Felicity, 'A Genre Beyond Grunge', *The Sydney Morning Herald*, 27 May 1994

Messham-Muir, Kit, 'Adam Cullen: Soft Material Facts', *Eyeline*, no. 25, Spring 1994

1993 Chapman, Christopher, 'Touch and Go', (cat. essay), 1993

Colless, Edward, 'Perspecta' (cat. essay), 1993

James, Bruce, 'A Good Clean Punch', *The Australian*, 9 October 1993

Lumby, Catharine, 'Adam Cullen: The Readymade', *World Art*, no. 1, November 1993

Lumby, Catharine, 'Hanging Around At Home', *The Sydney Morning Herald*, 8 November 1993

Rankin-Reid, Jane, 'Shirthead', *Art + Text*, no. 45, May 1993

Sullivan, Eve, 'Heterocampstick', *Art + Text*, no. 45, May 1993

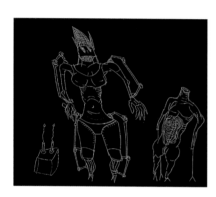

SPECIAL CONCERNS 2001
etching on paper
30 x 46 cm